Richard Shone

AUGUSTUS JOHN

PHAIDON

The author and publishers would like to thank all those museum authorities and private owners who have kindly allowed works in their possession to be reproduced.

Phaidon Press Limited, Littlegate House, St Ebbe's Street, Oxford
Published in the United States of America by E. P. Dutton, New York

First published 1979

© *1979 by Phaidon Press Limited*

ISBN 0 7148 1998 0

Library of Congress Catalog Card Number: 79-87453

Printed in Great Britain by Morrison & Gibb Ltd, Edinburgh

AUGUSTUS JOHN

There is a pronounced strain in English painting, as common in this century as it was in the last, of artists who begin very well and end very badly. Of course this is not peculiar to England, but as it has had relatively few outstanding artists who have matured well, the brilliant beginners with their dismal endings tend to be thrown into relief. There are a number of causes for this unhappy corrosion, and in Augustus John we can see the effects of most of them. John had magnificent beginnings – an ingratiating draughtsmanship allied to a flamboyant painting style – and he chose subjects which were both personal and widely compelling. But as the years passed, his work did little to justify a reputation which stood very high until the Second World War. Long before that, most painters in England regarded his talent as spent; young artists can be severely ungenerous in their critical appraisal, and to many John was an endearing social figure rather than an active aesthetic influence. The force of his personality ensured that where he drank or whom he painted was news; *how* he painted became virtually irrelevant. He was the most famous modern English painter with any claim to distinction. Nearly twenty years after his death, his position as a splendid failure arouses interest, although, as his inclusion in the present series of books bears out, his work is still popular.

Augustus John was immensely successful as a young man; his drawings were collected when he was still a student, he was given important commissions, and in John Quinn he found a wealthy American patron. But early success for painters can sometimes have a devastating effect. It invites them to take the line of least resistance, and social victories become confused with those won in the studio. Thomas Lawrence was Painter in Ordinary to George III at the age of twenty-two and deterioration gradually set in. We can follow David Wilkie and John Everett Millais from resounding early accomplishment to dim decline, and the same is true to a lesser degree of Edwin Landseer and Alfred Munnings. British painting is strewn with the fly-blown corpses of once gifted men. But early success is not wholly responsible for this pattern. John himself was aware of the pitfalls involved and never succumbed.

Many of the best painters in England have been predominantly lyrical in their expression, interpreting the English landscape through poetic or visionary eyes. Palmer springs immediately to mind, but we should forget neither Hilliard's youth among wild roses nor the anxious romanticism of several young artists in the 1940s. This lyrical mode belongs essentially to youth (as so often in poetry) and it is rare, though perfectly possible, for the artist to effect a successful transformation as he grows older. Alien to this lyrical expression are rigorous self-criticism, strong intellectual powers of construction, and that ambitious thinking-through of pictures which is noticeable in French and Italian painting. England has not had great decorators or muralists, and few artists in the last hundred years have been convincing on a large scale. Stanley Spencer is an exception among those working in John's lifetime.

Social conditions and class structure have often been hostile to the mature development of painters in England. There was neither the church patronage of Roman Catholic countries, which enabled artists to work on a large scale, nor an especially visually enlightened Court (music and architecture were more favoured there). The spoils of the Grand Tour from Italy and France were often regarded as luxury objects rather than as part of an inherited culture, and so imitation prevailed over understanding. Portraits gobbled up talent and time as one of the few ways a painter could earn a living. Augustus John relied on such income throughout most of his life. 'This curs'd Face Business', as portraiture's supreme martyr Gainsborough called it, destroyed the potential of many an agreeable gift, particularly in the eighteenth century and among John's generation.

Certainly the English have been very well recorded – not just their faces, but their habits and class, their parks and houses and Victorian slums, their fashions and temporary enthusiasms. But the inner, imaginative life fared less well as painters fulfilled the demands of clients and kowtowed to coarse and jolly aspects of popular sentiment. Many were killed with the kindness of success. There grew up a powerful establishment body which extracted its pound of flesh at the annual Academy and in the art schools, and which seems to have had incredibly little idea of what painting was about. While appearances continued to be recorded (and we now reap the burden of their social significance), hard thinking about painting and its relation to life was rare. Nor was there any equivalent in England of the considerable number of writers on art that we find in France and Germany. Whereas the Realist movement in France squarely faced the problems of painting in and for a modern civilization in ways that extended and enriched visual inheritance, English painters were caught between 'high' and 'low' art, little aware of the inappropriateness of the one or the corrosion inherent in the other. Of course there were some exceptions, but this misunderstanding of the nature of painting, and the consequent misdirection of activities, was so widespread that it is still disheartening to contemplate the waste of so much talent.

As we approach the period of John's student years (1894–8), dim lights shine out in reflection of recent French art. Whistler had his following, but the names of Monet and Renoir were becoming more familiar. Even so, strong talents who were temporarily fired by Impressionism – notably Wilson Steer – soon returned to a more stodgy, native diet. A vital contemporary school was impossible when convention and connoisseurship smothered fresh thinking. Camille Pissarro hit on this when contrasting the modern English and French schools: 'We have today a general concept inherited from our great modern painters, hence we have a tradition of modern art, and I am for following this tradition while we inflect it in terms of our own individual points of view.' (Letter to his son Lucien, 19 August 1898.) If the implications of Constable's and Turner's work had been understood, an alternative tradition might have evolved; but these artists were more actively appreciated abroad. We had to make do with the Pre-Raphaelites, who, in spite of occasional brilliance (in early Millais and Rossetti and in their associate Maddox Brown), were not the painters to found a vital tradition or sustain aspects of an older one – as much of their later work

bears out. Outstanding images were produced, paintings which can be taken as part of the history of English imaginative life; but for the rest, they simply do not deliver the goods beyond a tickling of our sentiments or an addition to our knowledge of the period. It is indisputable that there were painters with new, even revolutionary characteristics in Late-Victorian England (and they were by no means all French in origin), but they were fragmented, freakish and unrecognized. There was no flourishing avant-garde, as there was in Paris or Brussels or Munich, to offer an alternative to official insipidities or to distinguish what was fresh and invigorating. There was of course the New English Art Club (founded in 1886). There were the London Impressionists, who first exhibited in 1889 with Whistler as their mentor. There were English artists such as Steer and Edward Stott who exhibited with Les Vingt in Brussels from 1889, but there was little vital contact between them and their foreign fellow-exhibitors (such as Seurat, Van Gogh and Redon). Sickert, as usual, was an exception. When Augustus John was at the Slade School, interesting individuals were or had been working abroad (Robert Bevan and Roderic O'Conor in Brittany) or were already looking a little cosy as they adopted a half-way house between English genre and French *plein-airisme*. The influence of Monet was beginning to have direct consequences but even those painters with some feeling for recent French art were antipathetic to the concept of modernity. There was the empiricist's disregard of first principles which, while it encouraged the emergence of certain wilful talents, led to lazy borrowing and the endorsement of received opinion.

It may seem positively inflammatory to be so harsh about British art at the turn of the century (and to make no mention, for example, of Beardsley's European influence). Everyone is being or has been rehabilitated; the literature is becoming copious, and numerous sales and exhibitions of Victorian art testify to the revivalist ferretings of historians and dealers. This has had its advantages. A study of the subject-matter of much of the painting, for example, has revealed deeper and stranger currents than had been suspected before. But we will look in vain for surprising manipulation of colour, for formal innovation, or for evidence of a more conceptual approach to painting. It is not a question of simply wanting English painting to resemble that produced across the Channel; it is more that English artists seemed to be incapable of thinking about their work with the same rigour and clarity as the French.

All this may seem an unnecessarily long preamble to a brief account of the work of Augustus John, who, after all, was only twenty-two at the turn of the century. But it does place in perspective the difficulties confronting a brilliantly gifted student at that time. Was portrait painting to swallow him whole? Was he to study further in France? Should he maintain an English profile and start immediately to woo the Royal Academy? The situation was made more difficult for John in that he was not obviously an imaginative artist with a pressing urge to translate an inner vision as were Stanley Spencer or Paul Nash for example. Years later, he admitted to having been influenced by too many painters and that he should have kept to one only. But the complexity of the situation would not have been immediately apparent to the young Welshman, recently down from the Slade and burdened with the promise of a

brilliant future. Professor Tonks, his Slade School master, had described his drawings as unequalled since Michelangelo; Sargent, visiting the Slade, was of the same opinion. Sir Charles Holmes, no mean judge of painting, thought John a complete master as early as 1902. What is interesting about such encomia is that John was obviously needed; he arrived at just the right moment – gifted but unformed, unsure of his direction – when alert critics and connoisseurs had expressed dissatisfaction with contemporary art. He was made conspicuous at so early an age chiefly through his accomplishment as a draughtsman, for his painting in the early years of the century was confused in intention and variable in quality. It is significant that one of his finest early paintings, *Signorina Estella Cerutti* (Plate 1), relies on its drawn contour for effect rather than on the painterly bravura of other portraits of that time.

John's drawings first attracted attention to him – splendid Life Room productions in charcoal with lots of musculature disclosed by the even lighting of the studio. From then onwards, drawing was a major activity in his life: he drew family and friends (usually in pencil), imaginative figurative scenes (sketches for compositions, often in ink), drawings of the nude, and a constant flow of studies of his first wife Ida and his second wife Dorelia. Some of the best-known are those of Dorelia drawn about 1907–8. So familiar are they from reproduction that they have become difficult to look at objectively; certainly they are skilful, with a rather obvious beauty enhanced by their allusions to several Old Masters (from Parmigianino to Watteau). Dorelia – usually standing, self-absorbed, rarely looking out at the spectator, in flowing skirt and shawl – appears removed from daily life, diminishing that quality of observed visual fact which has been a continual feature of European figure drawing. On the other hand, many drawings of Dorelia are so polished and descriptive that one's immediate expectations run high; but prolonged study reveals them as thin and formally unexciting. Neither of these defects applies to a handful of drawings of John's children, who have been observed with an acuteness that remains potent. Such freshness, inherent in the subject, eludes him, however, in the often ludicrous poses of the Dorelia series. Supposedly hieratic gestures look stilted and sham in John's attempt to transform Dorelia into some enigmatic, other-worldly goddess.

But it must be said that such drawings were frequently studies for one of John's lifelong ambitions – the carrying out of large-scale works, full of figures whose significance would not be attributable to any story or particular incident (although many, as we now realize, are heavy with autobiographical content). Their configuration would induce a poetic mood similar to that which entranced him in the paintings of Watteau and Puvis de Chavannes and interested him in the *Saltimbanques* of Picasso (whom he had met in Paris in 1907). John longed to paint such compositions. 'When one thinks of painting on great expanses of wall,' he said in 1939, 'painting of other kinds seems hardly worth doing.' At the end of his life he was still fuming with frustration at his inability to finish any such work. I do not think, as some authors maintain, that the lack of patronage for large decorative works is to blame for John's failure; there were a good many murals executed between the wars for both public and private places and it was certainly known that to do one was an ambition of John's. Those he did attempt remained unfinished or never reached further than the

cartoon state. I think this failure is partly attributable to that absence of rigorous constructive powers mentioned earlier as a shortcoming of so many English painters. John's imagination in such works as *Lyric Fantasy* (Plates 35 and 36) or *Galway* (Tate Gallery) is not in doubt, and the former certainly contains eloquent passages; but the figures refuse to unify into a consistent rhythm. John's compositional difficulties are apparent on the canvas, for one can see various pentimenti of alternative positions; after working on the decoration for several years, John finally abandoned it, and this 'glimpse of the Golden Age' never materialized.

Such failures suggest a fundamental dislocation in the nature of John's gifts. On the one hand he wished to immerse himself in a poetic dream-world of beautiful women (sirens, muses, mothers) and lovely children abounding in echoes of Watteau, Puvis and Gauguin; on the other he was a proven realist in his portraits, in the Rembrandtesque etchings, and in the Halsian vigour of *The Smiling Woman* or *Ida Pregnant*. Sanction for such realism came from the old masters rather than from the realism of contemporary life as seen in Degas or Sickert. John was not at all in tune with the typical Camden Town Group subject – the back-rooms and iron bedsteads of North London, the soiled chemise or the gas cooker. He advised one young painter not to go to Sickert for instruction: 'He'll only teach you how to paint pisspots.' The two Welsh landscapes he contributed to the first Camden Town exhibition were considerably at variance with the majority of exhibits, though he is representative (with J. D. Innes and Walter Bayes) of its least characteristic wing. Enamoured of folklore, of untouched, untroubled landscapes, of the free, wandering life of the Romany gipsies, their songs and language, he could hardly be expected to paint, in Sickert's words, 'pages torn from the book of life'. If Gauguin's Tahitians or Picasso's strolling players seem equally removed from contemporary life, they are conceived by a completely modern sensibility; they never appear escapist, and John's gipsies, in spite of occasional contrary hints, emphatically do. As has been pointed out recently with reference to his large *Galway*, John had a 'regrettable tendency to theatricalize the proletariat'. To him they were picturesque, and that is something we never feel was in Gauguin's mind when painting the peasants in Brittany, or in Picasso's in Paris and Barcelona. But there is a group of pictures by John in which something of the dreamlike flavour he wished for in the large decorative works is perfectly conveyed. They are painted on panels no more than twelve by eighteen inches in dimension, spontaneously carried out in vivid colour with a minimum of preparation. Many were exhibited in 1910 and received strident abuse as meaningless, strange, 'uncouth and grotesque'. More recently – though they have never lacked admirers – they have been revalued as among John's most attractive works and an influential contribution to English modernism. Some were painted at Martigues in the South of France in 1910, others in Dorset, where the artist took a house in 1911. Nearly all are of women and children in a landscape, by the sea or on the shore of a lake. We can include in this group certain pure landscapes and a few portrait heads of his sons. *Dorelia with Three Children* (Plate 31) is a particularly fine example, ample in form, the figures perfectly spaced, the colour simple and economic; no details obstruct us and the whole small panel has a largeness and sense of life

which is lacking in John's more ambitious works. In this and similar pictures the paint is often emphatically yet fluently applied, direct onto small wooden panels; brief pencil lines left showing indicate the swiftness of execution. That careful knowledge of form instilled by Professor Tonks here comes into its own.

Until this period, the influence of other painters on John was strong and various, and although some enthusiasms remained constant, new ones were embraced and others discarded. His early admiration for El Greco was unusual at the time; we can see it in his Slade prize-winner of 1898 *Moses and the Brazen Serpent* and in many an elongated figure or tapering head from his later years. It reached a peak of absurdity in *The Heenburg Boys* (National Museum of Wales), two androgynous creatures in snake belts. John recognized that he had been too often swayed by others in his search for an individual style. If we look at the small panels and portraits of about 1910 to 1915, the influences are less apparent; they emerge from the Impressionist tradition (compare Manet's *On the Beach*) and have something in common with Gauguin's flat colour and with certain contemporary French painters such as Henri Lebasque or Louis Valtat. It has never been disputed that John was familiar with work by many of the painters represented in Fry's *Manet and the Post-Impressionists* exhibition of 1910; he had been in Paris on several occasions, had visited the *Indépendants*, and knew something of Fauvism (although in 1907, the year he met Picasso, he was asking who Van Gogh was). Familiar he may have been, but the implications of such work seem to have escaped him. Reading the articles he wrote for *Vogue* magazine in 1928 on modern painting, one is struck by his inability to understand or say anything particularly original about it, though there is some insight in his comments on a few English contemporaries, particularly Matthew Smith. Like many painters, he could be ruthlessly uncritical about his own work, treasuring inferior works and destroying fine ones (such as the drawing of *Caspar*, its pieces saved by its alert owner, Brinsley Ford). One can only speculate as to whether or not he realized how good his small works of the pre-War period were and how close they come to an original vision. Some have attributed the potency of this vision to John's Celtic origins; there is an indefinable melancholy about these figures – a mother and her children, sometimes accompanied by the sibylline presence of another woman, marooned in their timeless hats and draperies by lake and seashore. At other times, this Celtic strain is banished in favour of a bright, conscious naïvety, a childlike delight in raw colour (for example in *Romilly, Robin and Edwin* of 1911). But it is difficult to know how much John was interested in folk art or whether he knew the work of Rousseau. Certainly primitive art influenced a series of drawings at about this time, and in his account of a visit to Picasso, he later wrote of seeing there 'a large canvas [containing] a group of figures which reminded one a little of the strange monoliths of Easter Island'. But such influences are tentative, their implications never really carried through; the somewhat sculptural, monumental character of some of the figures in *The Way Down to the Sea* of 1909–11 (formerly Lamont Art Gallery, Exeter, New Hampshire) and *The Mumpers* of 1911–13 (Detroit Institute of Arts) appears contrived and at variance with the effete poses of the former and the attention to detail in the latter. The disquieting strangeness of such pictures comes more from John's stylistic quandaries

and hesitant attitude than from anything implicit in the subjects themselves. It is not unprofitable to see these small studies in relation to some of those French painters inspired by the people and landscape of Brittany, and to the brilliantly coloured panels of figures out of doors by Maurice Denis. John was familiar with Denis's work in Paris, and the French painter was represented at both Post-Impressionist exhibitions in London (although John expressed disappointment with Denis's one-man exhibition in London in 1912). The Breton subject-matter of Denis's friend Paul Sérusier has affinities with John's work, evoking a timeless, uncorrupted world. Such comparisons help to situate John in a broader European context, preventing a too insular estimation of these surprising and successful works.

The inspiration behind the Provençal panels and related works gradually diminished during the First World War. There were further attempts at large-scale compositions, including studies for *Canadians at Lievin Castle* of 1918, commissioned as part of the Canadian War Memorial scheme by Lord Beaverbrook. An oil study of one of the many Canadian soldiers John painted and drew is included here (Plate 40). A large oil sketch, *Fraternity* (Imperial War Museum), shows John at his most pedestrian in his inability to relate the three soldiers to the shattered building and broken trees behind them. Portrait painting took up more and more of his time and energy, although he never reached the super-professional degradation of an Orpen or a de Laszlo. Infinitely preferable to the string of commissioned works are later studies of his children (Plates 44 and 46) and a handful of portraits of women who continued to inspire him – Dorelia above all, Lady Cynthia Asquith, Lady Ottoline Morrell, Iris Tree, Lady Adeane, the Marchesa Casati. Plump models and robust barmaids make their appearance too among this galaxy of eminent beauties. John was a cultured man with arresting looks, an old-world courtesy and considerable conversational wit. He attracted distinguished writers as well as fashionable women. Among his sitters for drawings and paintings were Hardy and Shaw, the poet W. H. Davies, James Joyce and Oliver St John Gogarty, Arthur Symons and Ronald Firbank, Cyril Connolly and John's compatriot Dylan Thomas. These portraits have enough vigour to ensure their continuing appeal as likenesses of remarkable men, though none quite approaches the sensitivity of the earlier portraits of W. B. Yeats (Plate 3) or the brooding, economic Wyndham Lewis (Plate 4), a friend and champion of John for many years. The late study of Matthew Smith (Plate 49) shows that John could regain something of his former concentration in the portrayal of an old and admired colleague. Of his later landscapes (mainly of France), none can match the vivid purity of those done in 1911 and 1912 in North Wales in the company of J. D. Innes (1887–1914). Innes was one of the few contemporaries to have any direct influence on John's work (Modigliani, briefly, was another); and it was Innes who introduced John to the Arenig Mountain area of North Wales, where he produced such panels as *Arenig* (Leeds City Art Gallery) and *Llyn Treweryn* (Plate 30). Where Innes is often wildly melancholy and inventive in his colour, John gives a free but essentially naturalistic transcription of the scene before him. His assured tonal control and spontaneous touch put such small pictures among his most pleasing works. Later landscapes, frequently painted on holidays near St Rémy, Provence, are,

like the flower pieces, leisurely and charming but no more. The beauty of several Jamaican girls revived him, when visiting the West Indies in 1937, to a luscious use of paint and tender delineation of character. But John was immensely prolific all his life and there is much that is irredeemably bad – failures accentuated by the occasional well-drawn hand or a pair of eyes only he could paint. In 1929, when John was fifty-one, Virginia Woolf wrote of his exhibition at Tooth's gallery: 'I dashed into John's pictures . . . and there was so shocked that I came out again. You can't conceive – if I'm to be trusted – the vulgarity, banality, coarseness and commonplaceness of those works, all costing over £400 and sold in the first hour.' (Letter to Vanessa Bell, 28 April 1929.) Although he had an immense following after this period, critical opinion was not particularly favourable to him – whether in a 'bitter and brilliant attack' from Clive Bell (in the *New Statesman*, 4 June 1938) or in the more moderate criticism of Eric Newton: '. . . he has a serious, almost a fatal, weakness. His way of *seeing* is classic: his way of *painting* is baroque, and almost every serious picture he has painted suffers from this internal contradiction.' His reputation was still high in America, which he visited three times in the twenties, painting portraits and acting as British representative on the jury of the Carnegie Institute (1923). His fame across the Atlantic was founded on the huge representation of his work in the 1913 Armory Show; his reception in New York was more like that accorded to a film star or opera singer about to take the city by storm. Journalists and photographers were never far away from him in London, where he was an extremely well-known figure, continually being asked for his opinions on all kinds of matters and to exhibit in support of various causes. Even in the period after the Second War, a time of immense changes in English painting, John's presence was felt – *hors de combat*, certainly, but honoured – whereas painters who now appear increasingly substantial, such as Bomberg or Grant or Roberts, found difficulty in securing a regular dealer for their work.

After the First War, John's style altered little and his conception of a picture remained consistent. In his portraits he favoured quite simple backgrounds – a curtain or part of the studio wall. Thomas Hardy has his books, Lady Adeane her screen, the Marchesa Casati her Mona Lisa mountains. Head and torso are preferred to full-length figures; landscapes usually contain a solid architectural feature and a fairly high horizon. His flower-pieces invariably consist of a plain vase holding a few blooms of the same kind – peonies, magnolia, roses. One of the best of these, *Gloxinia*, was John's only submission to the 1955 Royal Academy and has something of the freshness of Manet's late flower paintings.

Elaboration was saved, in his later years, for his last attempt at a large figurative composition. This was a triptych based on the gipsy gatherings at Les Saintes Maries, celebrating Sara, the patron saint of the gipsies, and including mothers, children and an old musician. In studies for the work there are passages worthy of the young John, and the trembling line of his ageing hand gives them a certain vitality and lightness of touch. It was begun in the late forties and, much altered, was still unfinished when John died in 1961.

It is to the portraits we must return, for John is still generally regarded as the pre-eminent portrait painter of his time. In the latest volume of *The Oxford History of*

English Art (1870–1940) – a detailed study – John is, however, virtually unmentioned as such. Thirty or forty years ago, people would have been astonished at such an omission. After Sargent gradually abandoned portrait painting about 1910, portraits meant Augustus John. They meant Orpen and McEvoy, Kelly and Knight and Gunn, Lavery and de Laszlo; but it was John's name that counted, both here and abroad. It was a curious reputation, for his official portraits are relatively few and he was never an exponent of, in Denis Farr's phrase, 'Board Room verisimilitude'. Most of his best portraits were uncommissioned or done at the suggestion of a friend (such as Lady Gregory in the case of the early Yeats head, Plate 3). Many of his sitters John himself approached – particularly writers and fellow painters. Of public figures who sat to John there are some American State Governors, some politicians (Churchill, Mac-Donald), King Feisal of Iraq (painted in 1919 at the same time as his champion T. E. Lawrence), Montagu Norman of the Bank of England, and Gustav Stresemann, the German Chancellor (Plate 41). John's most elaborate *coup de théâtre* from between the wars is *Viscount D'Abernon*, in which the British Ambassador in Berlin stands in full ceremonial kit, one hand on the hilt of his sword, the other resting on a table in the manner of Moroni's *Gentleman* in the National Gallery. No one else in England could have brought off such a portrait so completely, introducing a note of wry amusement into something so essentially decorous.

But what a relief it is to turn to some of the portraits of his family and friends – to the studied insouciance of his daughter Poppet (Plate 44), painted at about the same time as he embarked upon D'Abernon. All is fresh and simple; it has that mixture of suavity and delicacy typical of John's best portraits, and shows a certain probity in its delineation of character. In recent years taste has gone against the set piece and the official portrait; Sargent's watercolours and small oil studies of his family and of friends like R. L. Stevenson and Vernon Lee are preferred to his commissioned works. Yet his reputation must stand or fall by them, for the rest is slight and secondary. Although we cannot compartmentalize John's output so clearly, it soon becomes obvious that his very best painting is to be found in the heads of Dorelia, Robin, Caspar, and others of his family, and in the small groups of women and children, a few landscapes, and a handful of portraits – of Lewis and Yeats, Joseph Hone and Eve Kirk, Ottoline Morrell and Matthew Smith. It is on these that the claim to take John seriously as a painter must depend.

Outline Biography

1878 Augustus Edwin John born at Tenby, 4 January, son of Edwin John, solicitor, and brother of the painter Gwen John (1876–1939).

1894–8 Studies at the Slade School of Fine Art, London.

1898 *Moses and the Brazen Serpent* wins Slade Summer Composition Prize. Visits Paris (autumn) and meets Whistler.

1899 First one-artist show at the Carfax Gallery, London (drawings).
 First exhibits with the New English Art Club.
 Painting near Etretat, Normandy, where he meets Charles Conder and poses for William Rothenstein's *The Doll's House* (Tate Gallery).

1901	Marries Slade student Ida Nettleship.
1901–2	Painting instructor at art school affiliated to Liverpool University. First paintings of gipsies; first etchings.
1902	Birth of David John. Meets Dorelia MacNeill.
1903	Elected to the New English Art Club. 'Works by Augustus and Gwen John', Carfax Gallery. Birth of Caspar John.
1903–7	With William Orpen runs the Chelsea School of Art.
1904	Birth of Robin John.
1905	Birth of Pyramus and Romilly John (sons of Dorelia MacNeill).
1907	In Paris (with Henry Lamb); meeting with Picasso. Birth of Henry John and death of Ida in Paris.
1908	With Dorelia and sons in London. Paints Lady Ottoline Morrell.
1909	Meets American patron John Quinn. *The Smiling Woman* (Tate Gallery) shown at the International Society's 'Fair Women' exhibition.
1910	At Martigues, South of France. Takes the Villa Ste Anne (sold in 1928). November: forty-eight *Provençal Studies* exhibited at Chenil Galleries, Chelsea.
1911	Elected to the Camden Town Group (exhibiting in June). Divides time between London and Alderney Manor, Dorset, with Dorelia and family. Works in North Wales with J. D. Innes (1887–1914).
1912	Painting in Ireland (summer). With Innes in North Wales. Birth of Poppet John.
1913	In Paris, where he meets Modigliani.
1914	President of the National Portrait Society.
1915	Birth of Vivien John. Paints George Bernard Shaw and Lloyd George, and plans *Galway*.
1916	One-artist exhibition, Chenil Galleries.
1917	One-artist exhibition, Alpine Club Gallery. In France (until early 1918), having accepted honorary commission in the Canadian Overseas Military Forces to work as war artist for the Canadian War Memorials Fund.
1919	Paints several portraits at the Paris Peace Conference.
1921	Begins best-known portrait *Madame Suggia* (Tate Gallery). Elected Associate of the Royal Academy.
1923	First visit to the United States. Paints Thomas Hardy.
1925	Small retrospective at the New English Art Club.
1927	Moves to Fryern Court, Hampshire, which remains his country home for the rest of his life.
1928	Royal Academician.
1929	Paints T. E. Lawrence.
1933	Trustee of the Tate Gallery (until 1941).
1937	Takes farmhouse (Mas de Galeron) at St-Rémy-de-Provence (until 1950); visits Matthew Smith (1879–1959) at Aix-en-Provence. Painting in Kingston, Jamaica.
1938	Resigns from the Royal Academy over rejection of Wyndham Lewis's portrait of T. S. Eliot; re-elected 1940.
1940	Elected to the London Group (Honorary Member with Kokoschka and Jack Yeats). Retrospective exhibition of drawings, National Gallery, London.
1942	Awarded the Order of Merit.
1944	Matthew Smith and John paint each other's portrait at Fryern Court.
1946	Retrospective exhibition, Temple Newsam, Leeds.
1948	Elected President of the Royal Society of Portrait Painters.
1949	Exhibition at Scott and Fowles, New York.

1954	Retrospective exhibition, Diploma Gallery, Royal Academy.
1956	Retrospective exhibition, Graves Art Gallery, Sheffield.
1958	Campaigns for nuclear disarmament and against capital punishment.
1961	Dies 31 October at Fryern Court aged eighty-three.
1969	Death of Dorelia John aged eighty-seven.

Select Bibliography

John, Romilly: *The Seventh Child: A Retrospect*. London, 1932.

Browse, Lillian: *Augustus John: Drawings*. London, 1941.

Rothenstein, John: *Augustus John*. London, 1944.

John, Augustus: *Chiaroscuro: Fragments of Autobiography* (First Series). London, 1952.

Cecil, David: *Augustus John: Fifty-two Drawings*. London, 1957.

Morrell, Ottoline: *Ottoline. The Early Memoirs of Lady Ottoline Morrell* (ed. R. Gathorne-Hardy). London, 1963.

John, Augustus: *Finishing Touches* (ed. Daniel George). London, 1964.

Chamot, Mary, Farr, Dennis, and Butlin, Martin: Tate Gallery Catalogues: *Modern British Paintings, Drawings and Sculpture* (vol. 1). London, 1964.

Devas, Nicolette: *Two Flamboyant Fathers*. London, 1966.

Rothenstein, John: *Augustus John* (The Masters, no. 79). London, 1967.

Lewis, Wyndham: *Blasting and Bombardiering* (revised edn.). London, 1967.

Holroyd, Michael: *Augustus John, a biography* (2 vols.). London, 1974–5.

Easton, Malcolm, and Holroyd, Michael: *The Art of Augustus John*. London, 1974.

Morrell, Ottoline: *Ottoline at Garsington. Memoirs of Lady Ottoline Morrell* (ed. R. Gathorne-Hardy). London, 1974.

Fitzwilliam Museum, Cambridge: 'Augustus John'. *Catalogue of the paintings, prints and drawings in the Fitzwilliam Museum*. 1978.

National Museum of Wales, Cardiff: *Augustus John: Studies for Compositions* (centenary exhibition catalogue by A. D. Fraser Jenkins). 1978.

Farr, Dennis: 'English Art 1870–1940' (*The Oxford History of English Art*, vol. 11). Oxford, 1979.

List of Plates

with notes on the portraits

1. *Signorina Estella Cerutti*. 1902. Oil on canvas, 91.5 × 71 cm. Manchester, City Art Gallery. One of John's earliest portraits and one in which the high quality of his draughtsmanship has not been swamped by a Halsian vigour of brushwork. The painting is unusually serene and tender. Estella Cerutti was a young Italian pianist who lived in the same house as Augustus John and his first wife Ida, 18 Fitzroy Street.

2. *W. B. Yeats*. 1907. Pencil, 24.8 × 21.6 cm. London, Tate Gallery.

3. *W. B. Yeats*. 1907. Oil on canvas, 49.5 × 43.8 cm. London, Tate Gallery.
W. B. Yeats (1865–1939) was with John at Coole Park in County Galway, the home of the writer Lady Gregory, when this early portrait was painted along with other studies (notably the painting in Manchester City Art Gallery). John had been asked to make an etching of the poet to be included in a collected edition of his works in 1908 (the etching was carried out but not used). 'Yeats, slightly bowed and with his air of abstraction . . .', wrote John. 'With his lank hair falling on his brow, his myopic eyes, his hieratic gestures, he looked every inch a poet of the twilight.' Yeats sat again for John in 1930 for a portrait now in Glasgow Art Gallery. The old distinction between 'early Yeats' and 'late Yeats' holds good for the portraits if no longer for the poet's own work.

4. *Wyndham Lewis*. About 1905. Oil on canvas, 80 × 61 cm. England, private collection.
When the painter and writer Wyndham Lewis (1882–1957) was at the Slade School of Fine Art, he was awed by John when the slightly older

painter paid occasional visits. They were introduced to each other in 1902 and in the following year John made two etchings of Lewis (Plate 5). This dramatic, swiftly painted portrait of a Lewis 'full of Castilian dignity' was probably painted in John's Fitzroy Street studio. At the time, Lewis was undecided whether to devote himself to painting or to writing. In fact he did both. In spite of the tremendous difference in their subsequent careers and several quarrels, Lewis and John remained friends. The strong outline and restricted colour anticipate the bold simplification of portraits such as *Head of a Girl* (Plate 13) of a few years later. Lewis himself made a pencil drawing of John in 1932.

5. *Wyndham Lewis*. About 1903. Etching and drypoint, 17.7 × 13.9 cm. London, Thos. Agnew & Sons Ltd.

6. *Portrait of Jane Ellen Harrison*. 1909. Oil on canvas, 63.5 × 76.2 cm. Cambridge, Newnham College (by courtesy of the Principal and Fellows).

Jane Ellen Harrison (1850–1928), classical scholar, anthropologist and lecturer, from 1898, in Classical Archaeology (and later Russian) at Newnham College, Cambridge. John received the commission indirectly through his acquaintance with the Darwin family. Jane Harrison, whose delightful *Reminiscences of a Student's Life* was published in 1925, was a friend of several leading scholars and writers of her time. Her interest in contemporary painting was encouraged by Roger Fry. Evidence of that interest is contained in the portrait itself – on the wall is Wilson Steer's pointillist-influenced *Procession of Yachts* (1892–3), bought from the artist by Miss Harrison and sold to the Tate Gallery in 1922. She was also responsible for Newnham's commission of Duncan Grant's *The Queen of Sheba* (Tate Gallery) in 1912. Her last years were spent mainly in Paris in the company of the writer Hope Mirrlees.

7. *Sir William Nicholson*. 1909. Oil on canvas, 190.2 × 143.8 cm. Cambridge, Fitzwilliam Museum.

William Nicholson's friend and biographer Marguerite Steen wrote that Nicholson's elfin quality was the one thing missing from John's 'grand full-length' of the painter. Nevertheless, something of Nicholson's distinction – his dandyism and studied finesse – is caught in one of John's more elaborate portraits even though he makes little of the background curtain. Nicholson (1872–1949) came to prominence with his Beggarstaff posters (in collaboration with James Pryde). Like John he was drawn into the lucrative business of portraiture but fortunately realized its debilitating effects. He returned, for the most part, to the landscapes and still-lifes which make him the doyen of the *petits maîtres* of modern English painting. The picture is one of the finest of that turn-of-the-century group of painters' portraits by painters – Sickert's of Steer and Rothenstein's of Conder are notable examples.

8. *Robin*. About 1912. Oil on panel, 45.1 × 30.5 cm. London, Tate Gallery.

9. *Caspar*. About 1909. Oil on panel, 40 × 32.4 cm. Cambridge, Fitzwilliam Museum.

10. *Ida in the Tent*. 1905. Oil on canvas, 37 × 45 cm. Private collection.

11. *David and Dorelia in Normandy*. About 1907. Oil on canvas laid upon millboard, 37 × 45.5 cm. Cambridge, Fitzwilliam Museum.

12. *Alick Schepeler*. 1906. Pencil on paper, 21.6 × 21.6 cm. Cambridge, Fitzwilliam Museum.

The best of John's drawings of Alick Schepeler, who, at the time of this study, was a twenty-four-year-old secretary with the *Illustrated London News*, exceptionally attractive and, it appears, incredibly uninteresting. But she enthralled John and he was inspired to make one of his finest series of drawings. Her reign over John's affections lasted for about two years until early 1908. She also posed for a large painting, *La Séraphita*, destroyed by fire in the 1930s.

13. *Head of a Girl*. About 1908. Oil on panel, 40.6 × 32.4 cm. London, Tate Gallery.

14. *The Archer*. About 1907. Oil on panel, 53.3 × 36.8 cm. Collection of Marcus Wickham-Boynton.

15. *Study of a Boy*. 1910. Oil on panel, 43.2 × 31.8 cm. Cardiff, National Museum of Wales.

16. *Study of a Whippet*. About 1906. Pencil, 28.3 × 35.6 cm. Barnsley, Cooper Art Gallery. Reproduced by permission of the Trustees of the Cooper Art Collection in conjunction with South Yorkshire County Council.

17. *Pyramus Asleep*. About 1906. Pen and brown ink on paper, 10.2 × 27.3 cm. The John Estate.

18. *Child Study: Pyramus*. About 1908. Pencil, 43 × 20 cm. London, collection of Mrs Thelma Cazalet-Keir.

19. *Portrait of a Woman*. 1901. Pencil, 17.5 × 17.5 cm. London, collection of Mrs Thelma Cazalet-Keir.

20. *Two Studies of a Male Nude*. About 1900. Charcoal, 61 × 47 cm. London, British Museum.

21. *The Blue Pool.* 1911. Oil on panel, 31.8 × 49.5 cm. Aberdeen Art Gallery.

22. *The Red Feather.* 1911. Oil on panel, 32.5 × 40.5 cm. Private collection.

23. *Dorelia by the Gate.* 1910. Oil on panel, 52.7 × 31.1 cm. Ottawa, National Gallery of Canada.

24. *Washing Day.* About 1912. Oil on panel, 40.6 × 30.2 cm. London, Tate Gallery.

25. *A Woman Standing.* About 1911–12. Oil on panel, 39.5 × 32 cm. London, collection of Mrs Thelma Cazalet-Keir.

26. *An Hour at Ower (Dorset).* 1914. Oil on panel, 34.3 × 49.5 cm. London, collection of Mrs Thelma Cazalet-Keir.

27. *Robin.* About 1915. Oil on canvas, 52 × 42 cm. Private collection.

28. *Pyramus.* About 1910. Oil on panel, 38.5 × 31.5 cm. Private collection.

29. *Port du Bouc.* 1910. Oil on panel, 23.5 × 31.7 cm. Southampton Art Gallery.

30. *Llyn Treweryn.* 1912. Oil on panel, 31.5 × 40.5 cm. London, Tate Gallery.

31. *Dorelia with Three Children.* About 1910. Oil on panel, 23.5 × 32.9 cm. Cambridge, Fitzwilliam Museum.

32. *Near the Villa Ste Anne.* 1910. Oil on canvas, 27 × 32 cm. Private collection.

33. *A Study of Ida Nettleship.* About 1907. Charcoal, 63.4 × 36.6 cm. Cambridge, Fitzwilliam Museum.

34. *Two Heads of a Boy (Edwin).* About 1911. Pencil on light brown paper, 31.8 × 22.9 cm. Private collection.

35. *Lyric Fantasy.* 1910–11. Oil on canvas, 234 × 470 cm. London, Tate Gallery.

36. Detail of Plate 35.

37. *Peasant Woman with Baby and Small Boy.* About 1907. Charcoal and tempera on paper laid upon canvas, 181 × 81.5 cm. The John Estate.

38. *Lady Cynthia Asquith: Portrait of a Lady in Black.* 1917. Oil on canvas, 86.3 × 63.5 cm. Toronto, Art Gallery of Ontario.

'I made several attempts', John wrote in *Chiaroscuro*, 'to capture Lady Cynthia's strange satyr-like charm. Perhaps in one of these efforts I succeeded in approaching it, but like so many projects, it began, I think, better than it ended.' And Lady Cynthia wrote in her diary: 'He made – I think – a very promising beginning of me sitting in a chair in a severe pose: full face, but with eyes averted – a very sidelong glance. He said my expression "intrigued" him, and certainly I think he has given me a very evil one – a sort of listening look as though I was hearkening to bad advice.' (Lady Cynthia Asquith: *Diaries 1915–18*, '9 October 1917'; London, 1968.) Lady Cynthia Asquith (1887–1960) was the eldest daughter of the eleventh Earl of Wemyss and married Herbert Asquith in 1910. For several years she was a friend of and secretary to J. M. Barrie, about whom she later wrote a book. She was also a friend of D. H. Lawrence, who addressed a series of important letters to her during the First War. Her best known achievement was a series of ghost-story anthologies.

39. *Lady Ottoline Morrell.* About 1919 (or earlier). Oil on canvas, 66 × 48.5 cm. Oxfordshire, collection of Mrs Julian Vinogradoff.

During their love affair in 1908, John painted and drew Lady Ottoline Morrell (1873–1938) on innumerable occasions. She had been dazzled by him from the start: 'His dark auburn hair was long and cut across the front like a fringe, and with a square beard, his curious pale face and sea-anemone eyes, he might have been a Macedonian king or a Renaissance poet. He had a power of drawing out all one's sympathy,' John in his turn was one of the few people closely involved with Lady Ottoline who succeeded in keeping her friendship, and later called her 'the delicatest and noblest woman' he had known.

40. *Canadian Soldier.* 1918. Oil on canvas, 72.4 × 52.7 cm. London, Tate Gallery.

At the end of 1917 John obtained a commission as official war artist to the Canadian War Records under Lord Beaverbrook; Major John's electrifying appearance in France (he and the King were the only officers in the Army to wear a beard) is amusingly described by Wyndham Lewis in *Blasting and Bombardiering*. He made many drawings and paintings of Canadian soldiers, studies for a large composition destined for Lord Beaverbrook's Canadian War Memorials Gallery. Only a charcoal cartoon and two versions in oil (one incomplete) were executed; as late as 1959 Beaverbrook was still hoping John would deliver the final work.

41. *Portrait of Gustav Stresemann.* 1925. Oil on canvas, 109.3 × 78.7 cm. Buffalo, N.Y., Albright-Knox Art Gallery.

John visited Berlin in the spring of 1925 and, through the offices of the British Ambassador Lord D'Abernon (whom he was also to paint), Gustav Stresemann (1879–1929) was persuaded to sit for him. At the time, Stresemann was

negotiating the Treaty of Locarno with Aristide Briand and Austen Chamberlain, and from 1926 (the year he shared with Briand the Nobel Peace Prize) he was an important figure in the League of Nations. John was fascinated by Stresemann's appearance and thought him 'an *excellent* fellow, most sympathetic, intelligent and even charming'. The uncompromising view of the Chancellor given by the portrait was wrongly thought to be John's political comment on a man whom many distrusted.

42. *Portrait of Eve Kirk*. About 1928. Oil on canvas, 91.4 × 60 cm. Rochdale Art Gallery.
Eve Kirk, who studied at the Slade School from 1919 to 1922, was a friend of John, a landscape painter and decorative artist. She had been almost crushed by the severities of Professor Tonks's teaching at the Slade and it was only later in the twenties, with encouragement from John, that she resumed painting. She had various one-artist shows in London including an exhibition at the Paterson Gallery in 1930 with a catalogue envoi written by John. In 1955 she went to live in Italy and gave up painting; she died in 1969. There is a landscape of Avignon by her in the Tate Gallery, London.

43. *The Marchesa Casati*. 1919. Oil on canvas, 96.5 × 68.5 cm. Toronto, Art Gallery of Ontario.
The daughter of a Milan industrialist, Luisa Ammon married into one of Italy's noblest families and became one of the most famous and extravagant hostesses in Europe. She was an inspiration to the Italian Futurists (who admired speed above all things), the mistress of d'Annunzio, and the inspiration in 1914 for one of Boldini's most electrifying portraits. In twenty years or more she ran through several fortunes and during the 1930s could be found desperately keeping up appearances in London through the charity of old friends like John. He painted two portraits of her in April 1919; the other, which he presented to the Marchesa, is now in a private collection in Dorset.

44. *The Artist's Daughter (Poppet)*. About 1927–8. Oil on canvas, 63.5 × 45.5 cm. Melbourne, National Gallery of Victoria.

45. *Lady Adeane*. 1929. Oil on canvas, 188 × 96.5 cm. Collection of the late Sir Robert Adeane.
A portrait of the first wife of the late Sir Robert Adeane. She was Kit Dunn, the daughter of the Canadian financier Sir James Dunn who was a patron of John and of Sickert, from whom he commissioned several portraits. Although the figure of Lady Adeane is strikingly evocative of the period, John typically tired of bringing the whole picture to a conclusion and it remained unfinished. It was first exhibited at the Royal Academy Summer Exhibition of 1951.

46. *David*. About 1920. Oil on canvas, 50.8 × 66 cm. London, The Fine Art Society Ltd.

47. *The Poet Roy Campbell*. About 1930. Oil on canvas, 86.5 × 63.5 cm. Pittsburgh, Carnegie Institute, Museum of Art.
Throughout his life John was attracted to poets and writers, and some of the resulting portraits must be numbered among his best. He never surpassed the melancholy delicacy of the early Yeats (Plate 3) and his synoptic drawings of Joyce and Ronald Firbank are brilliant *bonnes bouches*. In this portrait of Roy Campbell we see John's hasty and fluent middle-period style. Campbell was a Roman Catholic convert, a supporter of Franco, ex-cowherd, fisherman and soldier. He had also attended lectures in Oxford, was a linguist and translator. He was described by the painter Nina Hamnett as 'very beautiful indeed', with 'wonderful grey eyes with long black eyelashes' and 'an odd gruff voice . . .'. Campbell was killed in a motor accident in Portugal. His autobiography *Light on a Dark Horse* was published in 1931.

48. *Head of a Jamaican Girl*. 1937. Oil on canvas, 39.4 × 32.4 cm. Collection of Mr Richard Burrows.

49. *Sir Matthew Smith*. 1944. Oil on canvas, 61 × 50.8 cm. London, Tate Gallery.
Matthew Smith (1879–1959) and Augustus John had been acquaintances since about 1910 and Smith married Gwen Salmond, a friend of John's from Slade School days. John greatly admired Smith's work – 'one of the most brilliant figures in modern English painting', he wrote of him in *Vogue* in 1928. With Smith's return to England from France in 1940, their friendship ripened; they painted each other and frequently met in London. One of John's last visits abroad, in 1956, was to see Matthew Smith in Aix-en-Provence and visit the Cézanne retrospective there which John found 'overwhelming'. This perceptive and moving portrait was painted in the autumn of 1944 when Smith, devastated by the loss of his two sons in the war, was staying with the Johns at Fryern Court.

50. *Self-Portrait*. About 1938. Oil on canvas, 40.6 × 34.3 cm. London, collection of Mrs Thelma Cazalet-Keir.

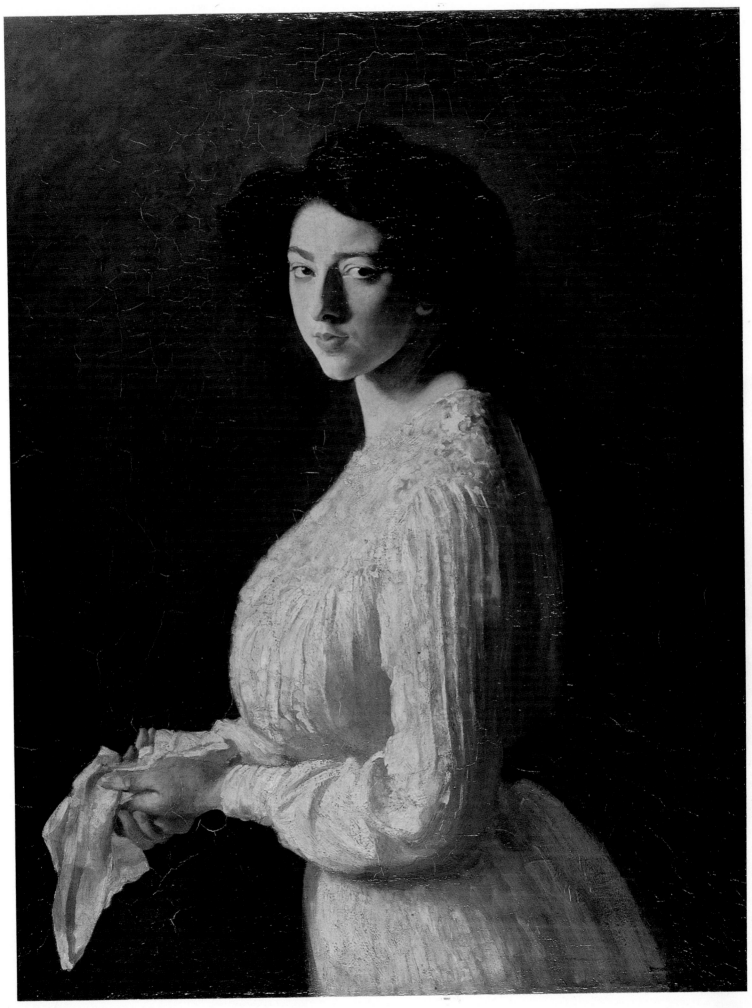

1. *Signorina Estella Cerutti*. 1902. Manchester, City Art Gallery

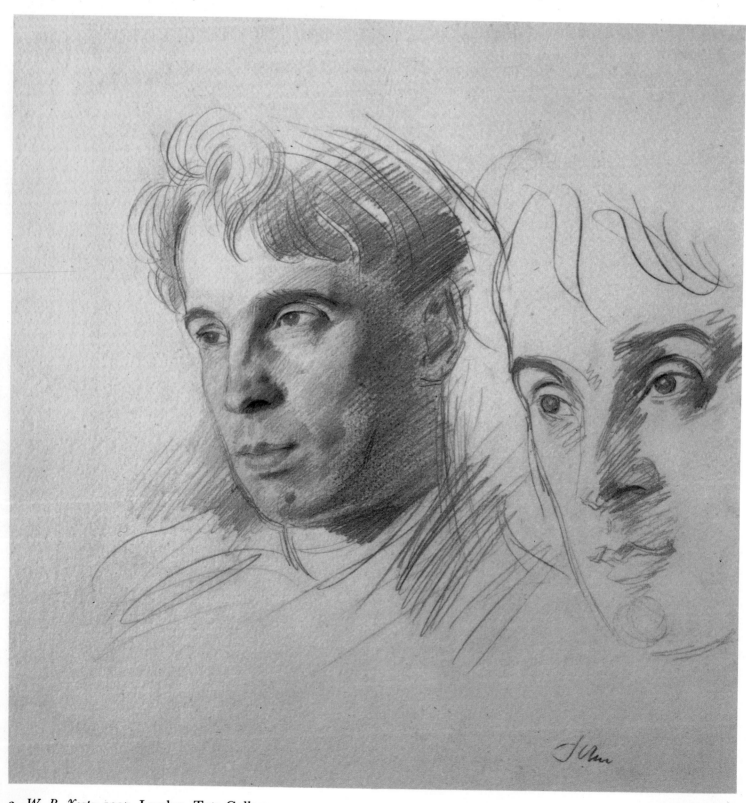

2. *W. B. Yeats.* 1907. London, Tate Gallery

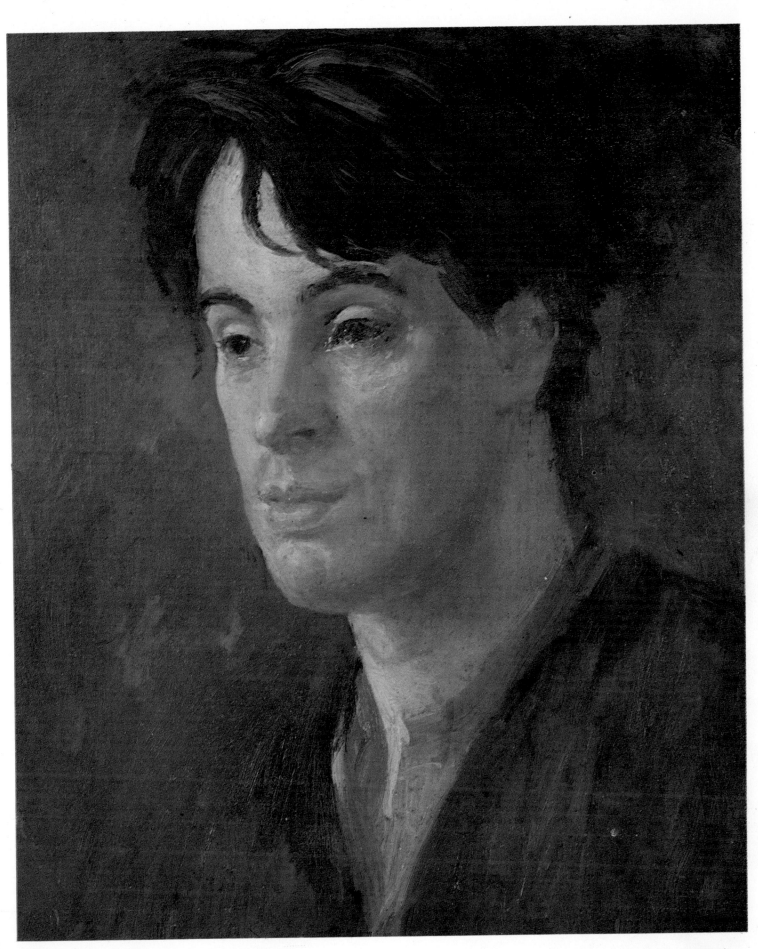

3. *W. B. Yeats.* 1907. London, Tate Gallery

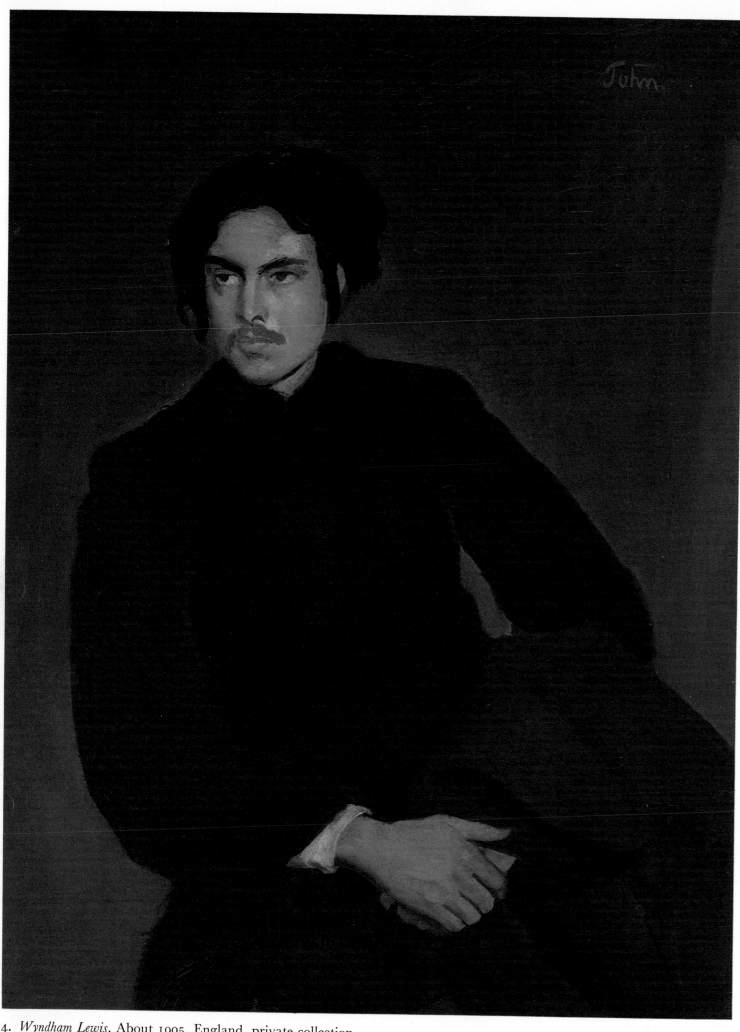

4. *Wyndham Lewis*. About 1905. England, private collection

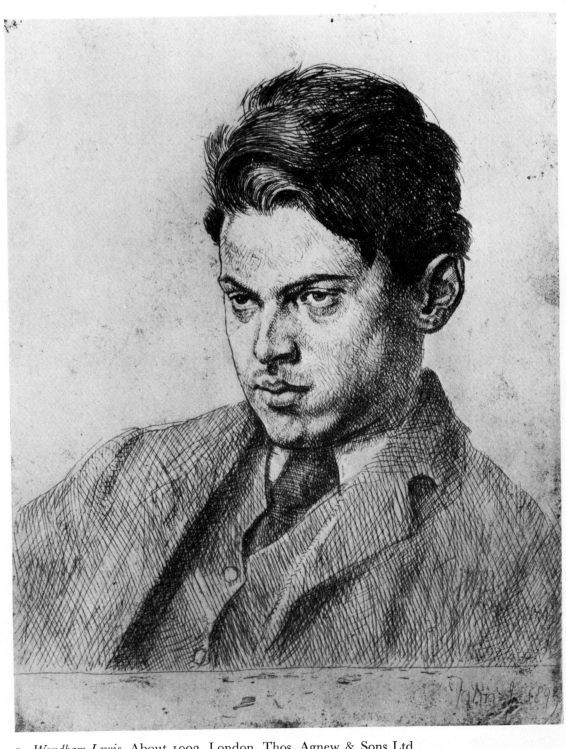

5. *Wyndham Lewis*. About 1903. London, Thos. Agnew & Sons Ltd

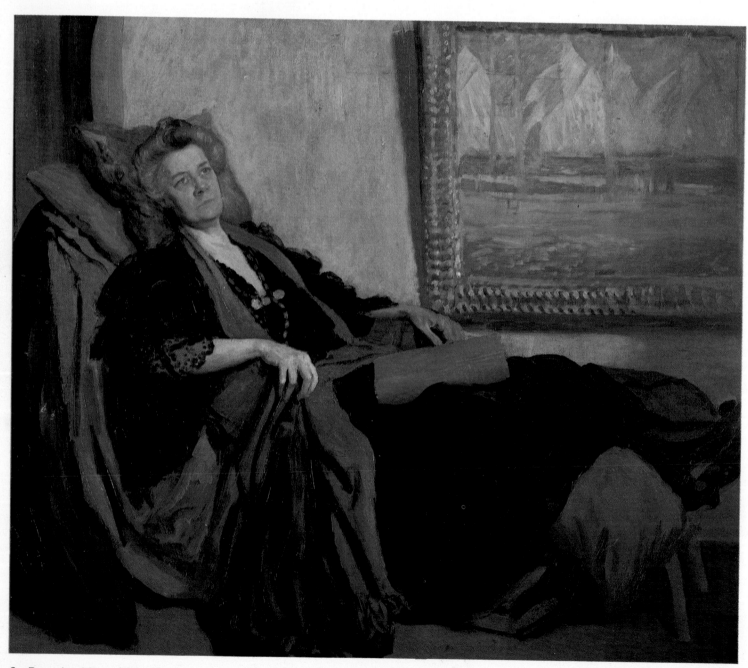

6. *Portrait of Jane Ellen Harrison*. 1909. Cambridge, Newnham College

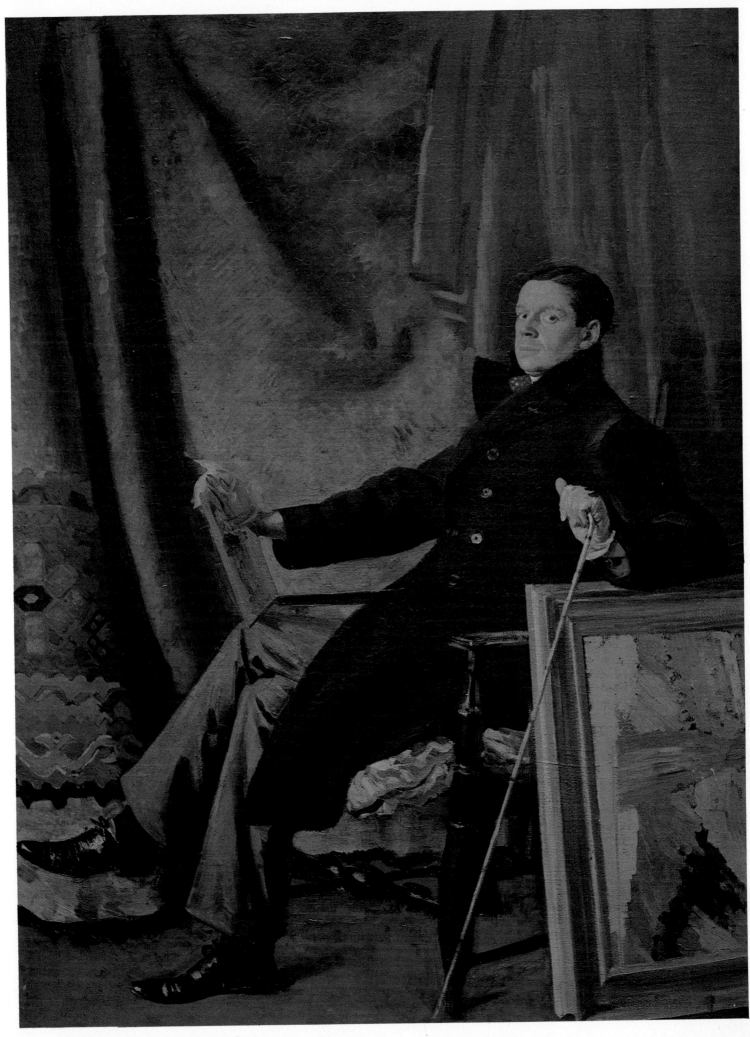

7. *Sir William Nicholson*. 1909. Cambridge, Fitzwilliam Museum

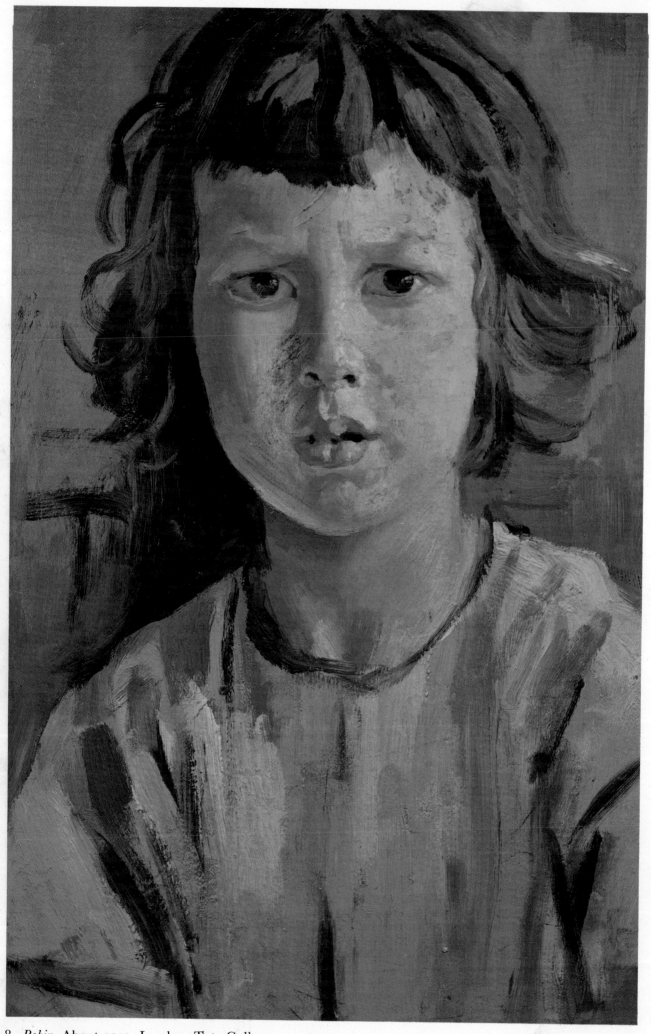

8. *Robin*. About 1912. London, Tate Gallery

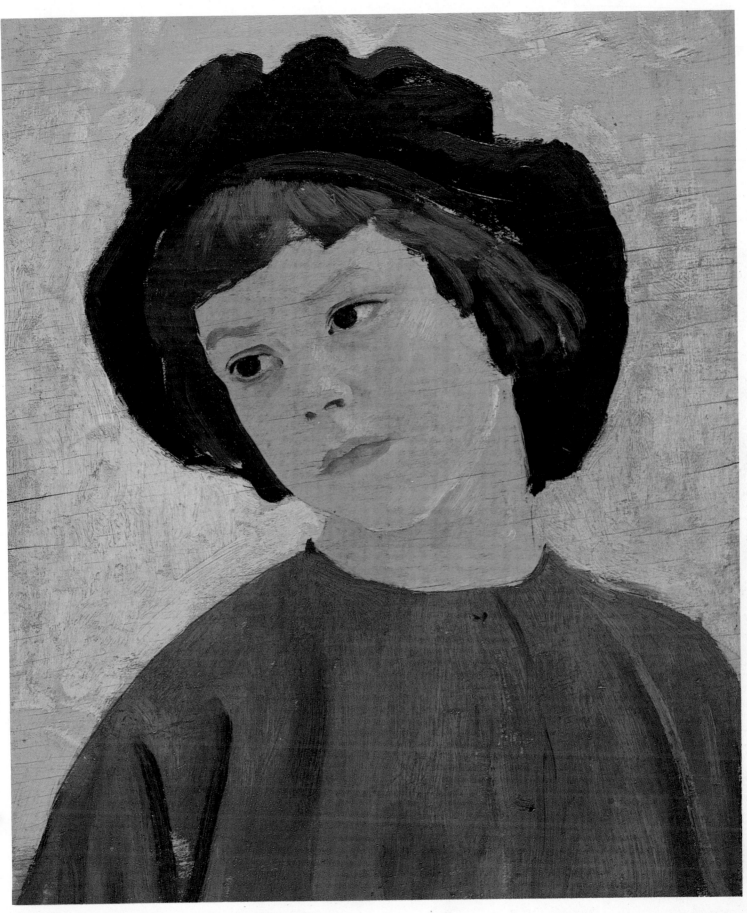

9. *Caspar*. About 1909. Cambridge, Fitzwilliam Museum

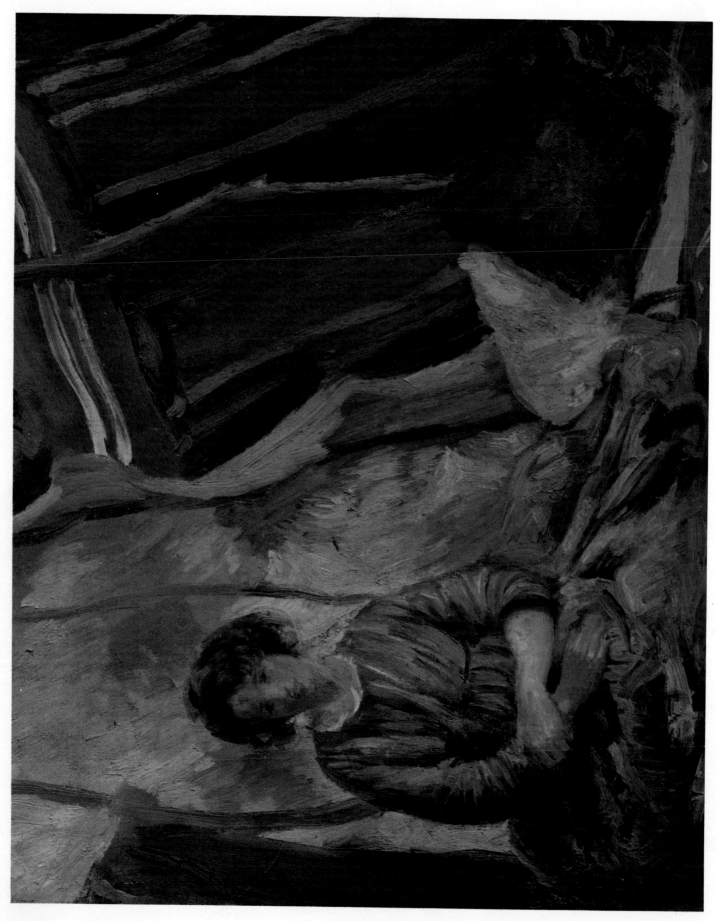

10. *Ida in the Tent.* 1905. Private collection

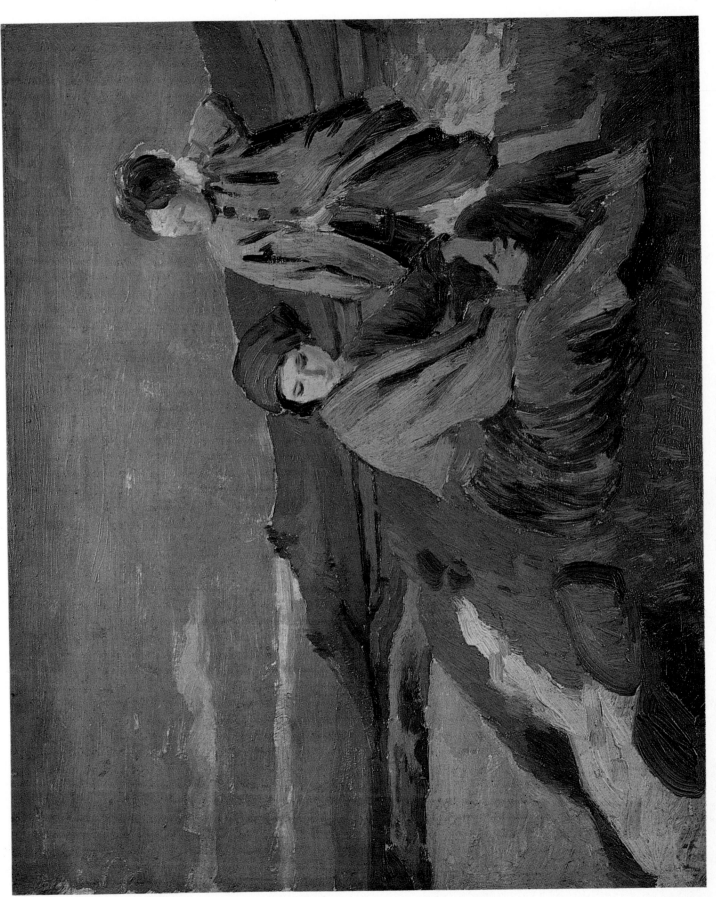

11. *David and Dorelia in Normandy*. About 1907. Cambridge, Fitzwilliam Museum

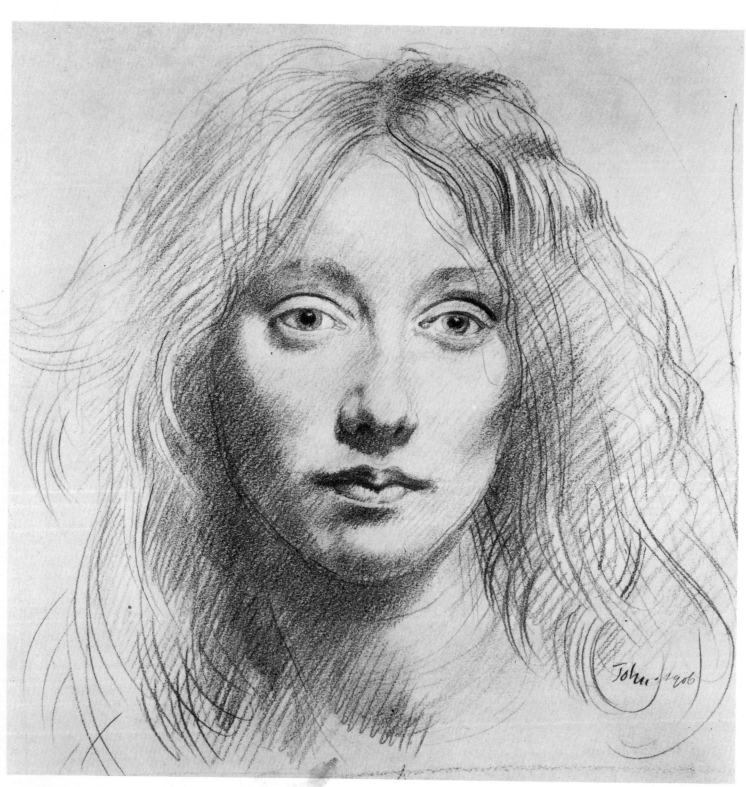

12. *Alick Schepeler*. 1906. Cambridge, Fitzwilliam Museum

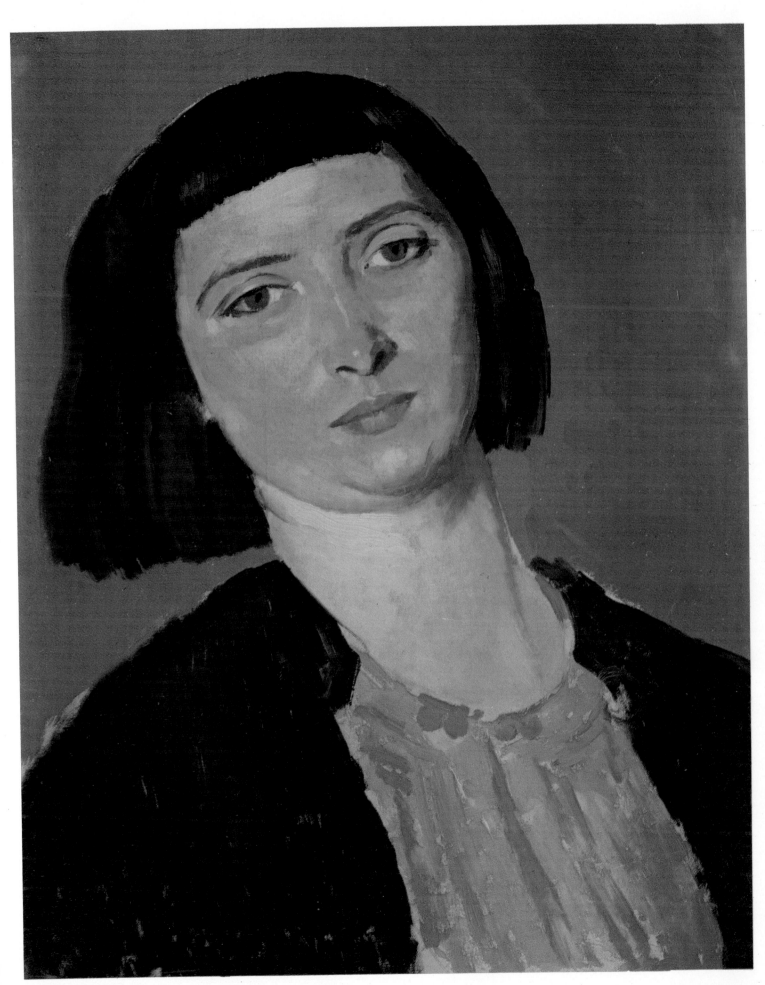

13. *Head of a Girl*. About 1908. London, Tate Gallery

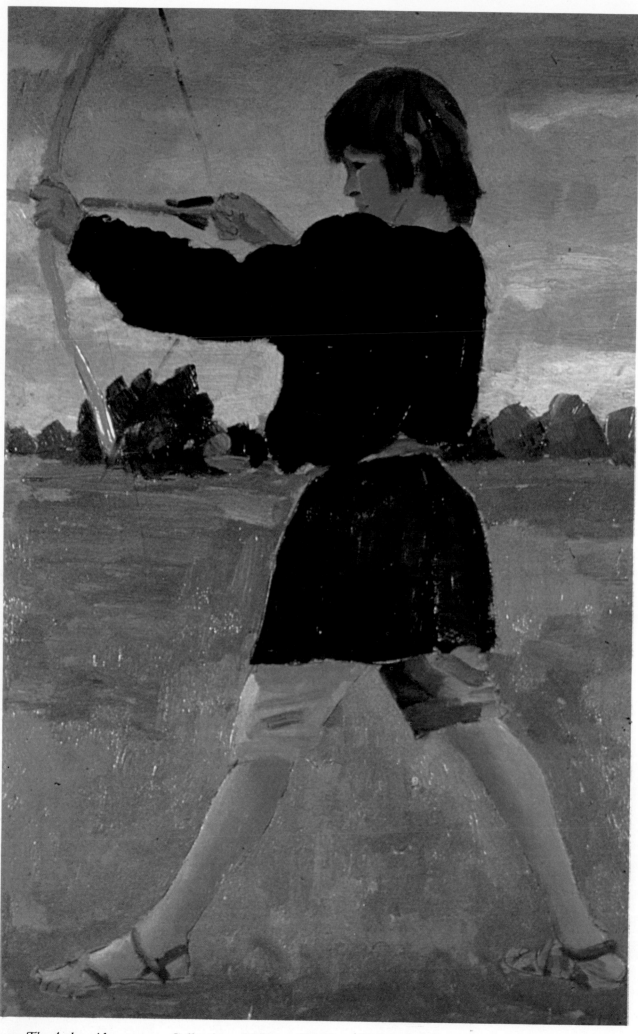

14. *The Archer*. About 1907. Collection of Marcus Wickham-Boynton

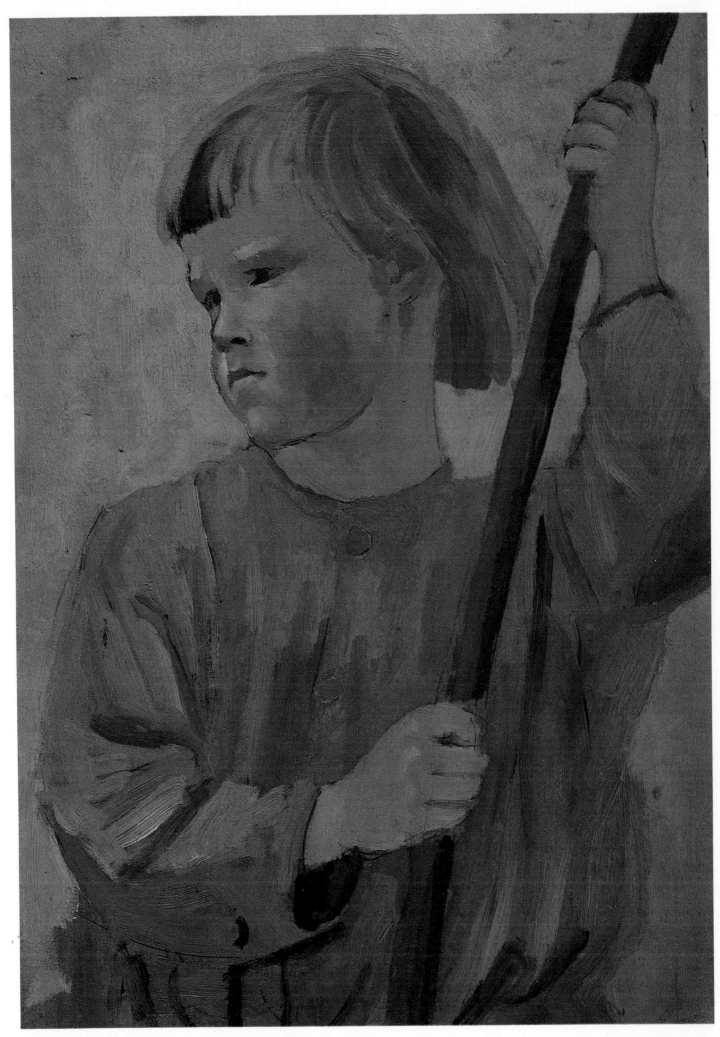

15. *Study of a Boy*. 1910. Cardiff, National Museum of Wales

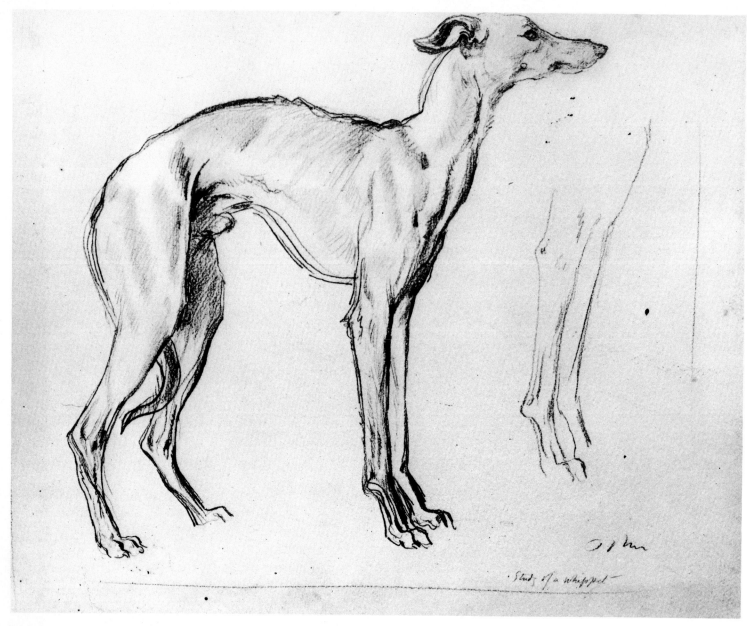

16. *Study of a Whippet*. About 1906. Barnsley, Cooper Art Gallery

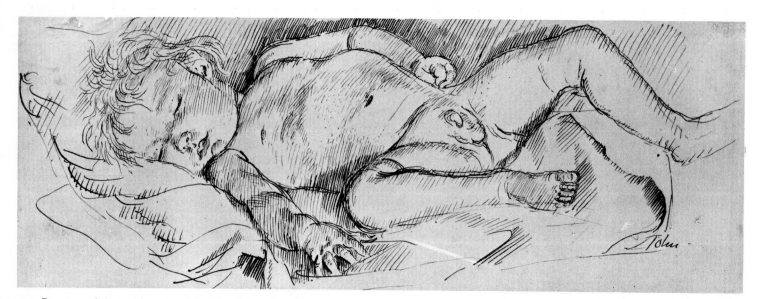

17. *Pyramus Asleep*. About 1906. The John Estate

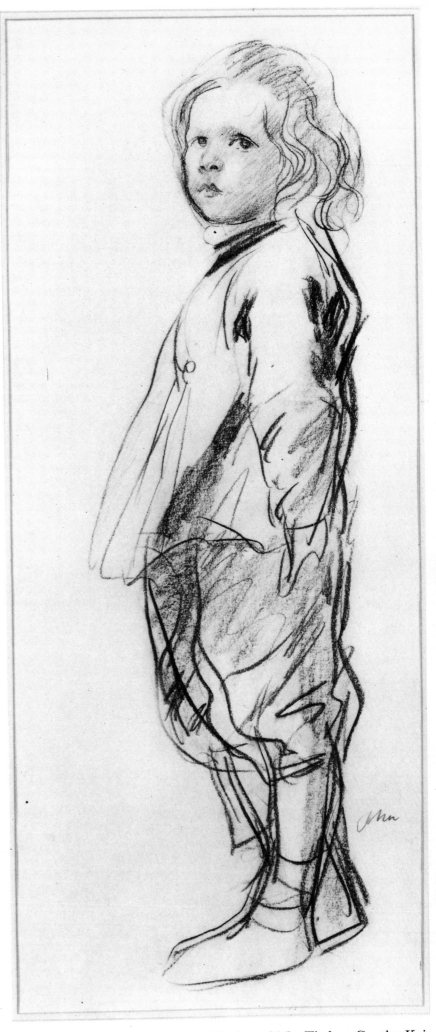

18. *Child Study: Pyramus.* About 1908. London, collection of Mrs Thelma Cazalet-Keir

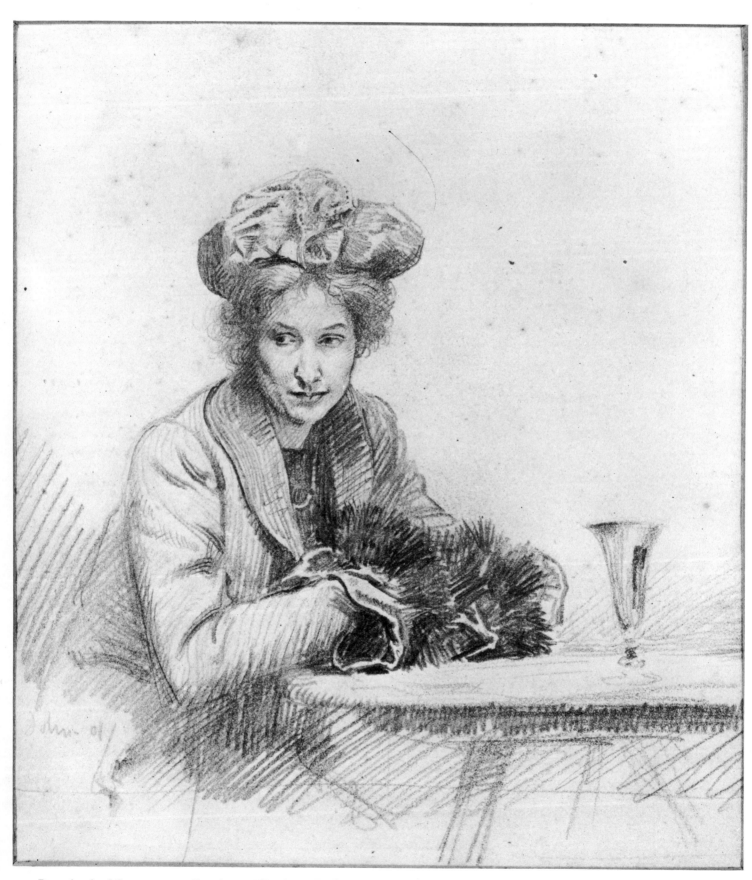

19. *Portrait of a Woman*. 1901. London, collection of Mrs Thelma Cazalet-Keir

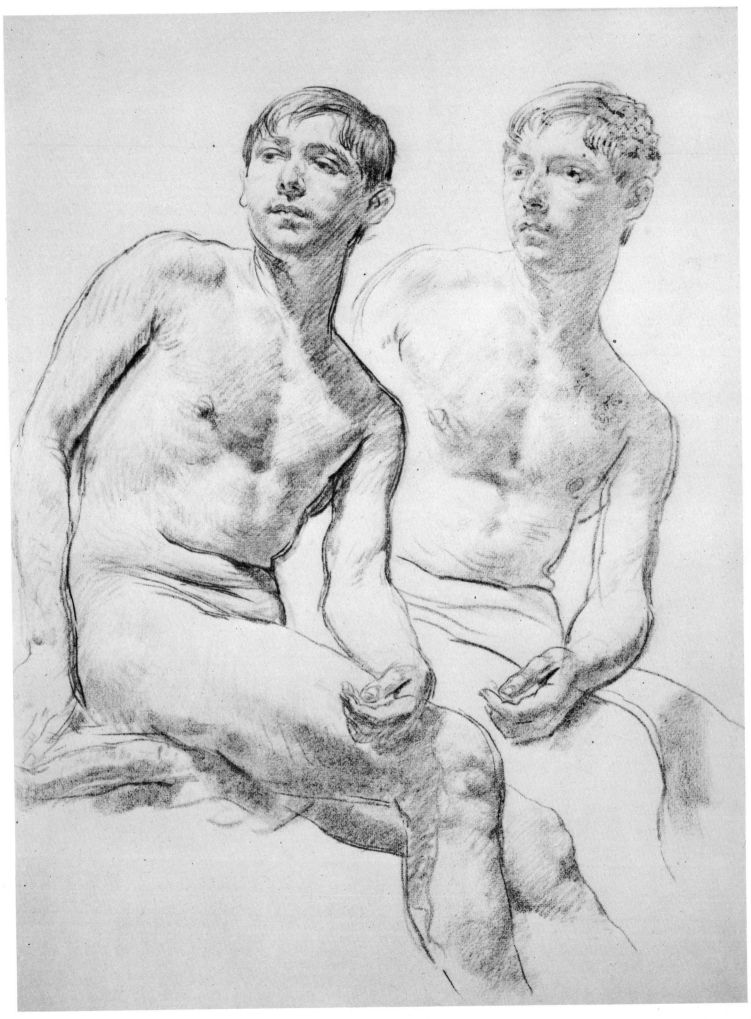

20. *Two Studies of a Male Nude*. About 1900. London, British Museum

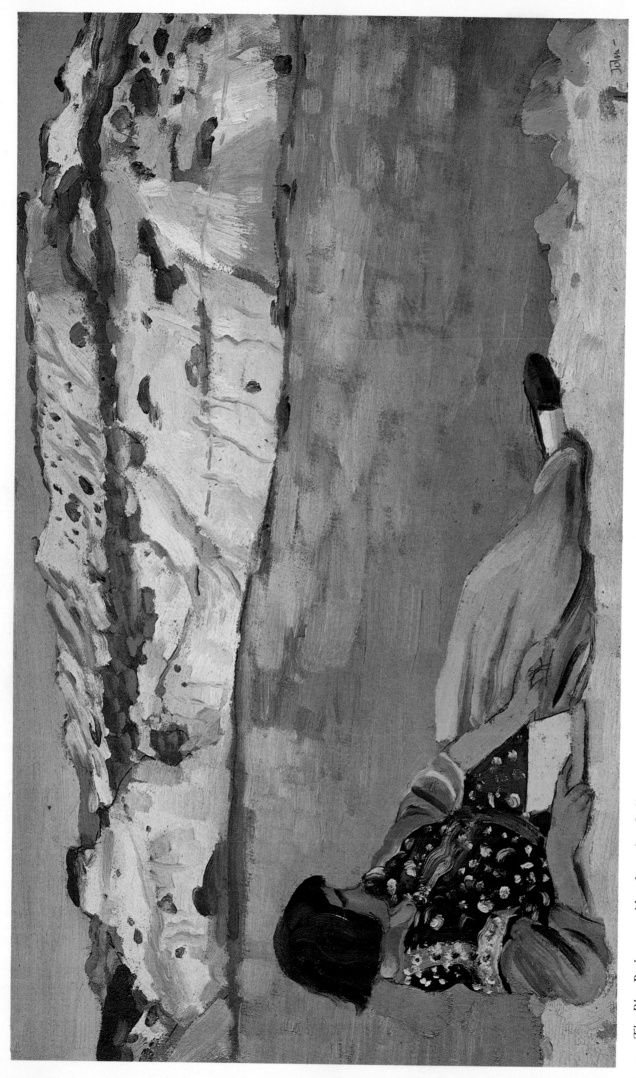

21. *The Blue Pool*. 1911. Aberdeen Art Gallery

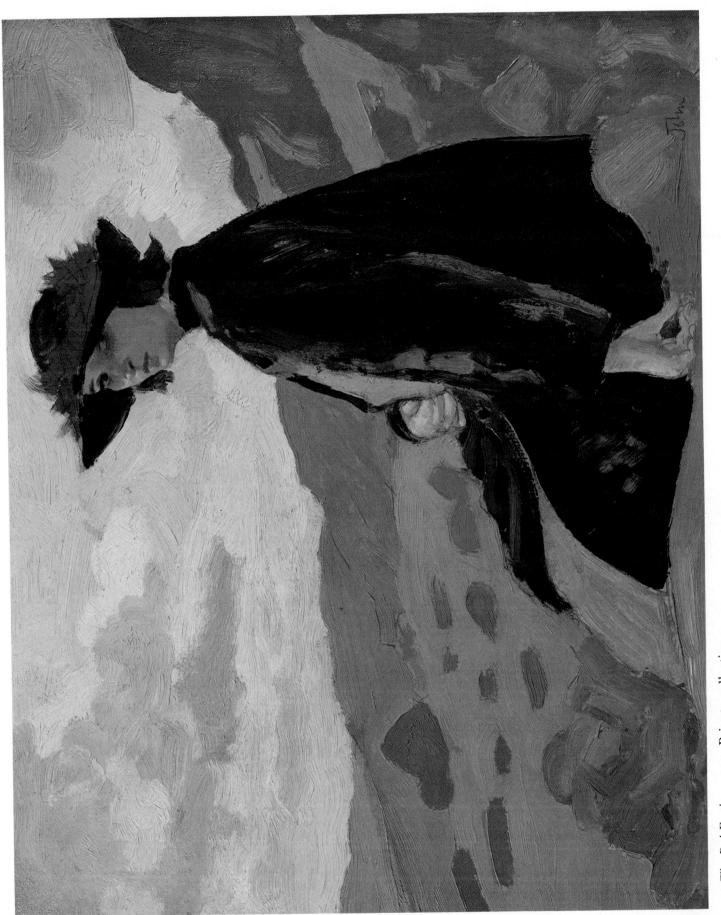

22. *The Red Feather.* 1911. Private collection

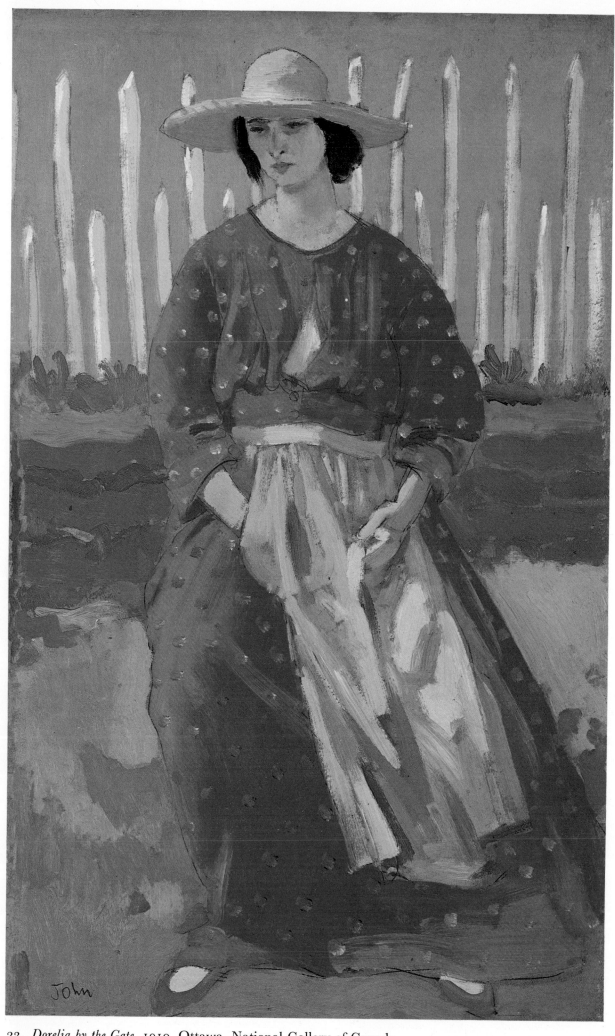

23. *Dorelia by the Gate.* 1910. Ottawa, National Gallery of Canada

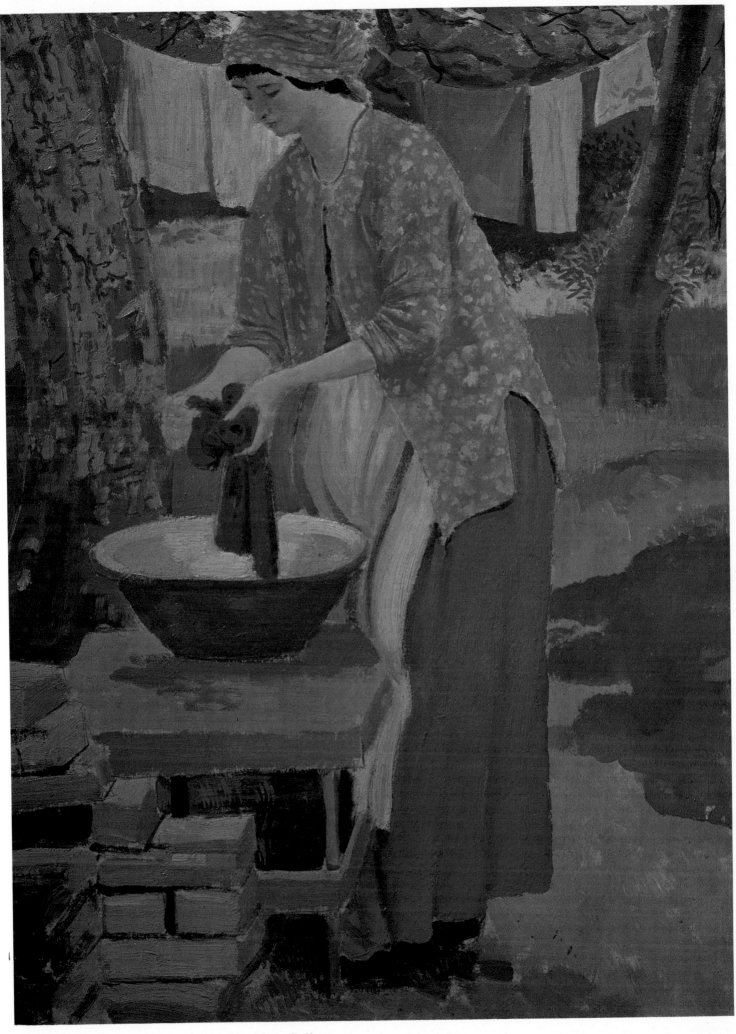

24. *Washing Day*. About 1912. London, Tate Gallery

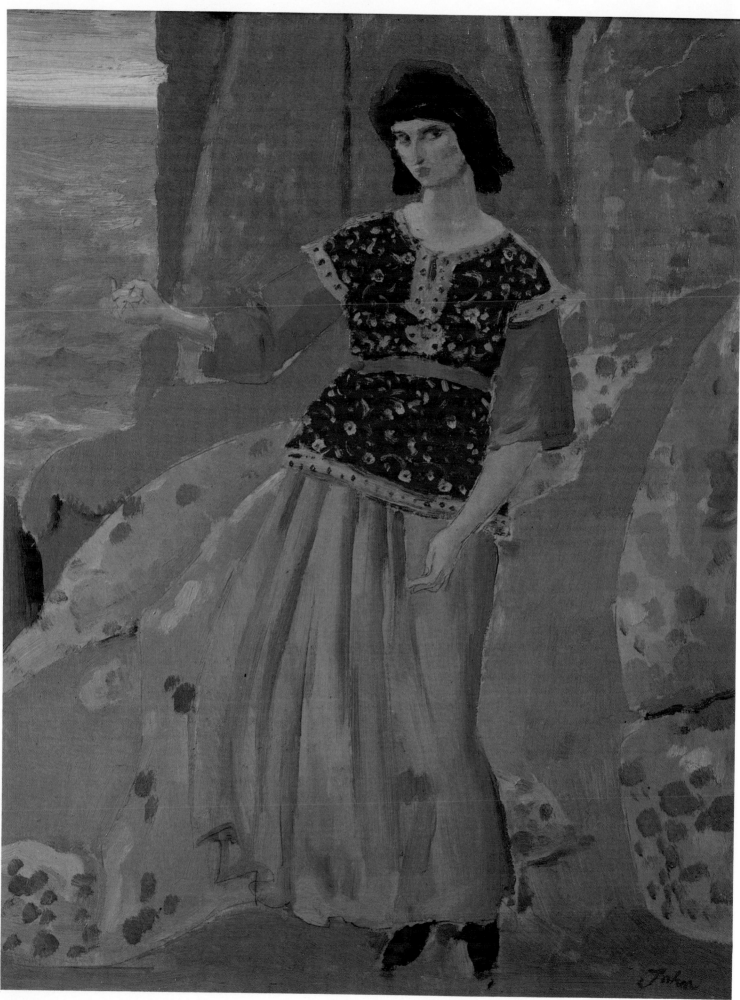

25. *A Woman Standing*. About 1911–12. London, collection of Mrs Thelma Cazalet-Keir

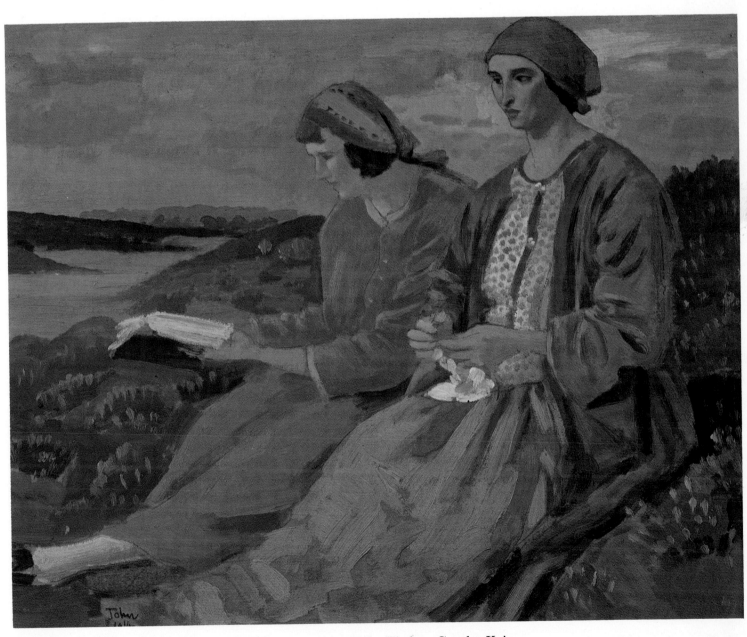

26. *An Hour at Ower (Dorset)*. 1914. London, collection of Mrs Thelma Cazalet-Keir

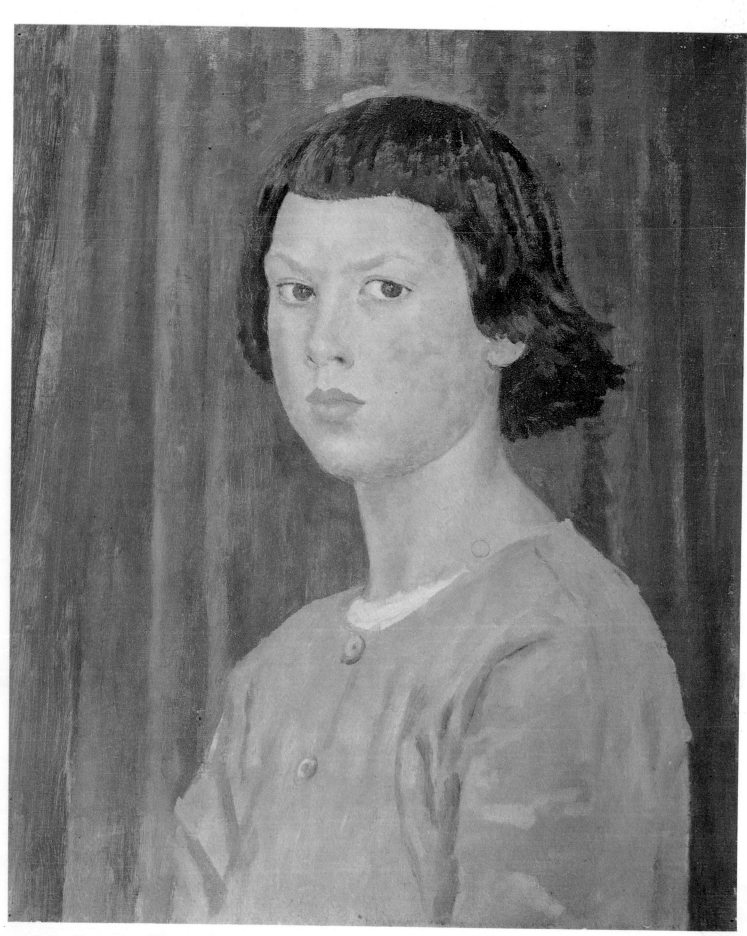

27. *Robin*. About 1915. Private collection

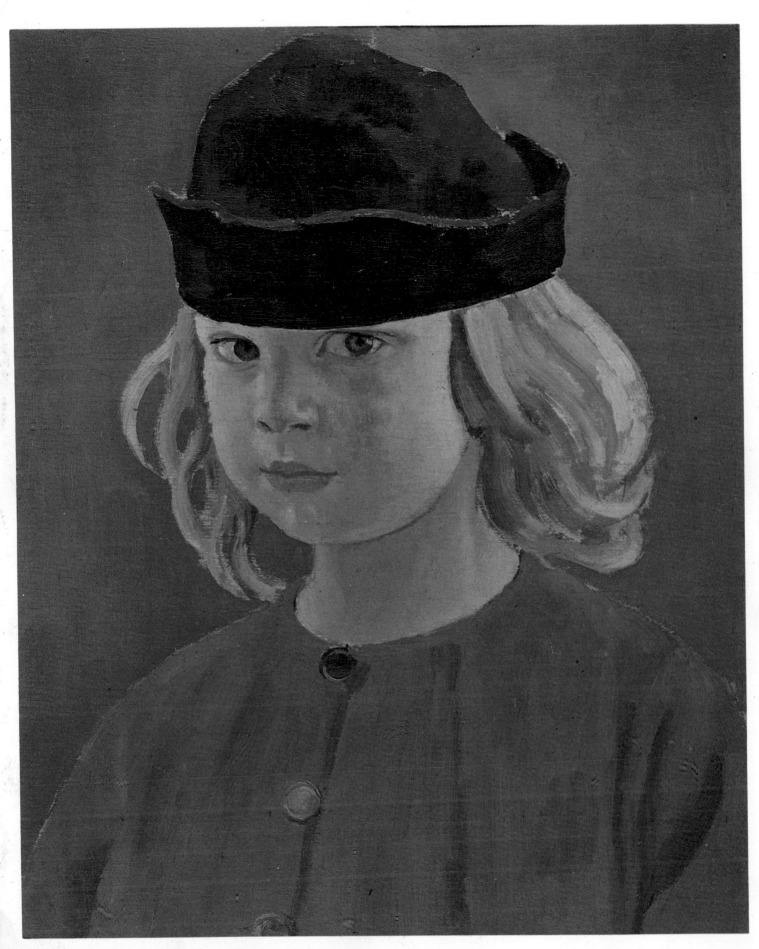

28. *Pyramus*. About 1910. Private collection

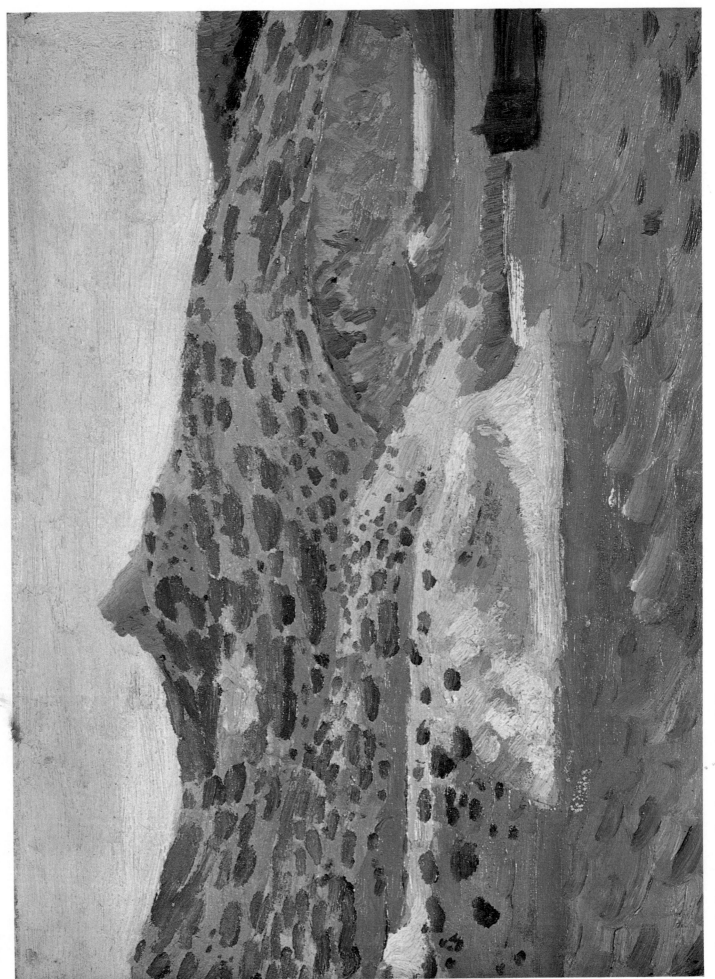

29. *Port du Bouc.* 1910. Southampton Art Gallery

30. *Llyn Treweryn*. 1912. London, Tate Gallery

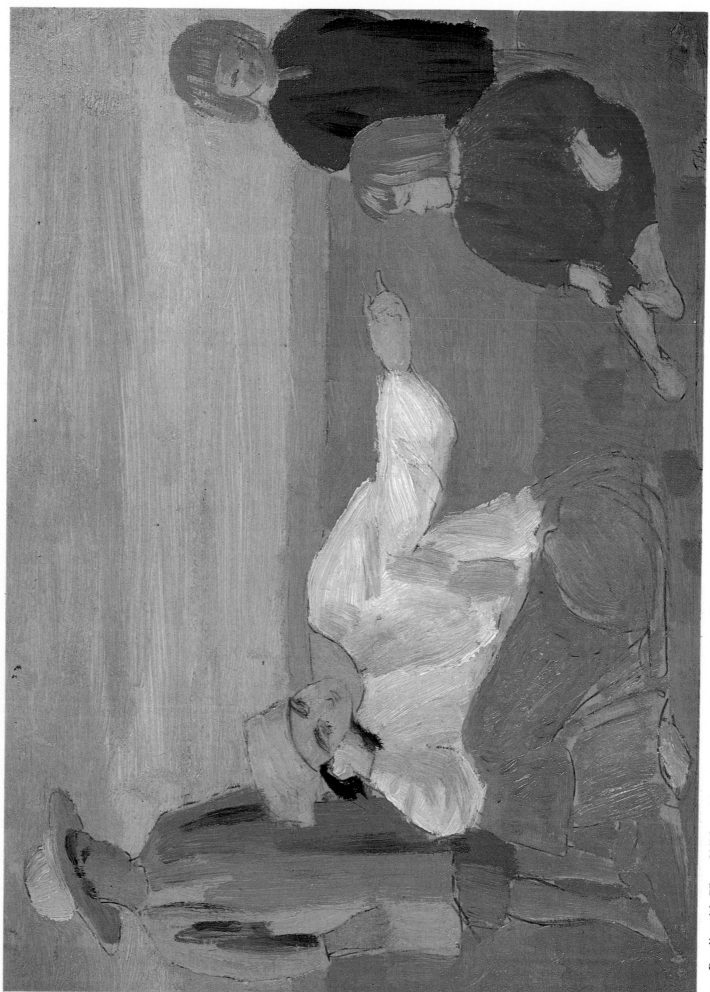

31. *Dorelia with Three Children*. About 1910. Cambridge, Fitzwilliam Museum

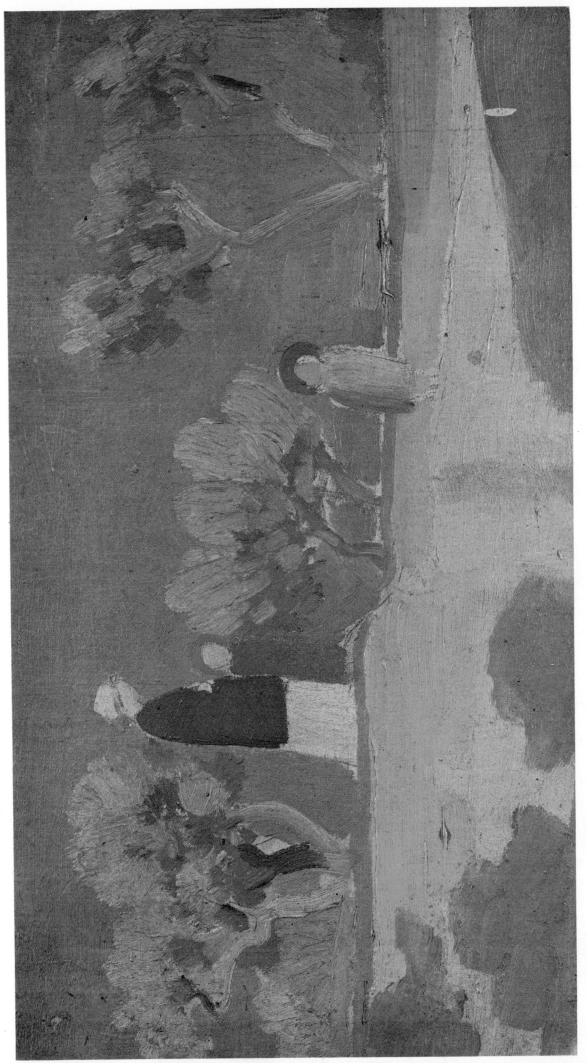

32. *Near the Villa Ste Anne*. 1910. Private collection

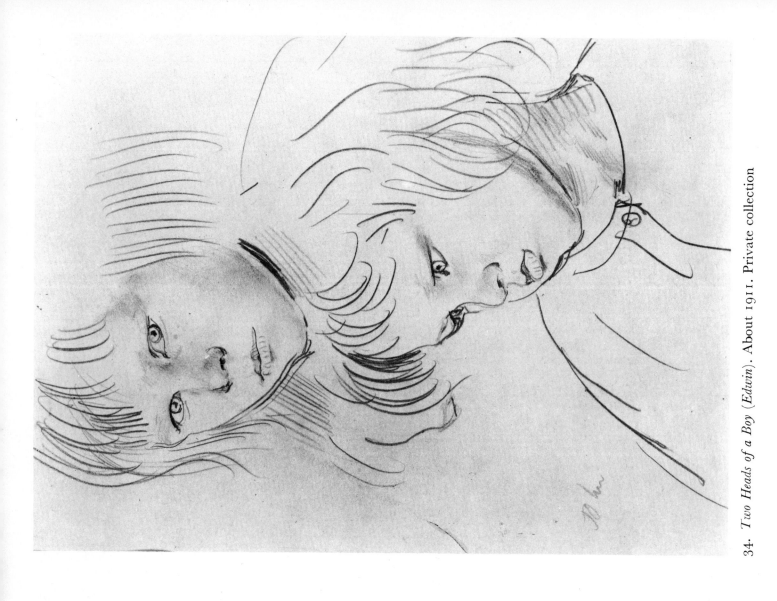

34. *Two Heads of a Boy (Edwin)*. About 1911. Private collection

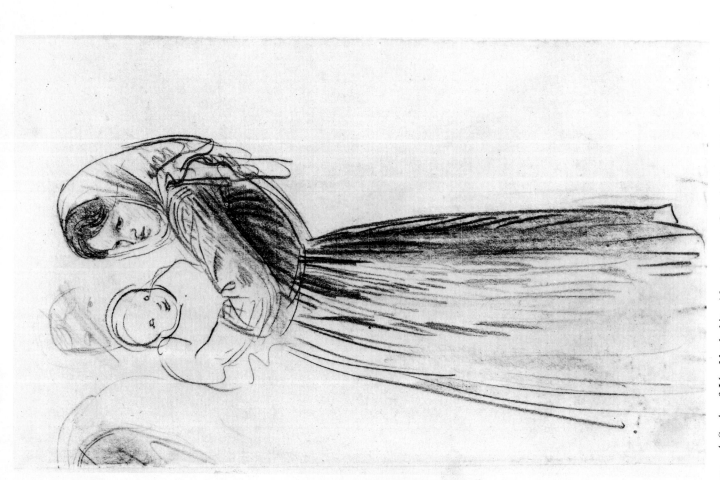

33. *A Study of Ida Nettleship*. About 1907. Cambridge, Fitzwilliam Museum

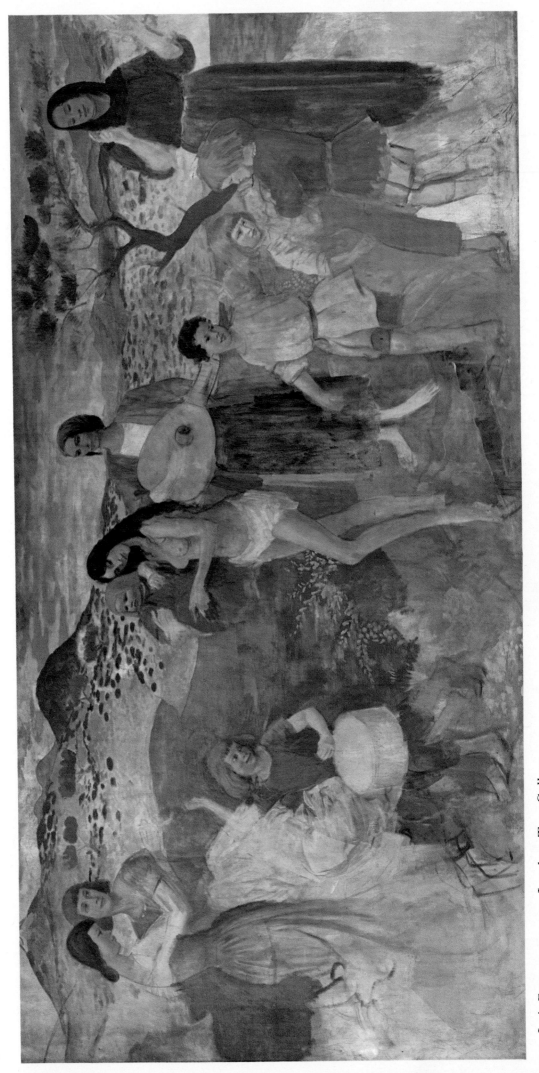

35. *Lyric Fantasy.* 1910–11. London, Tate Gallery

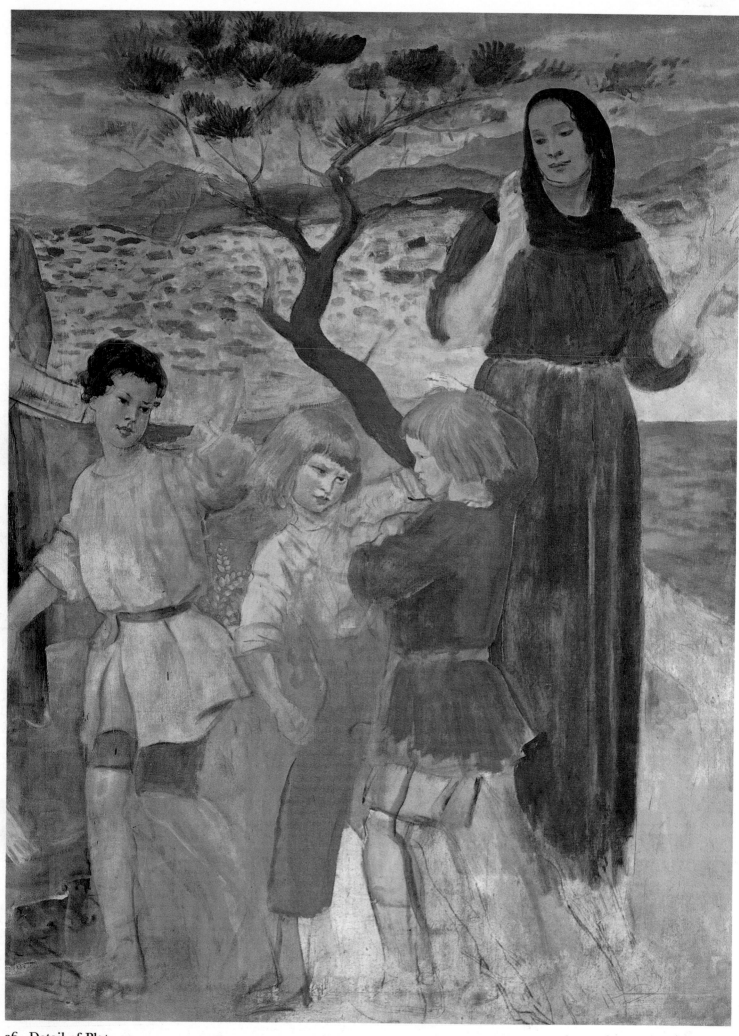

36. Detail of Plate 35

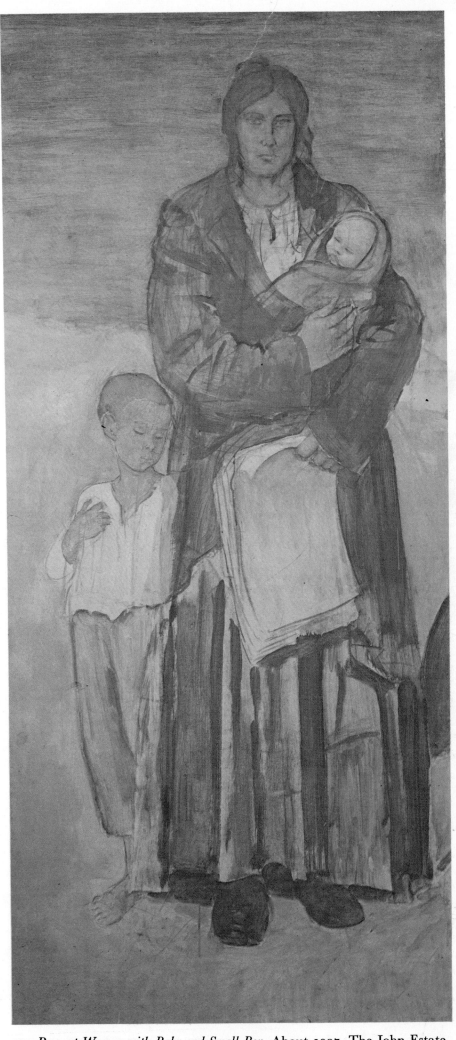

37. *Peasant Woman with Baby and Small Boy*. About 1907. The John Estate

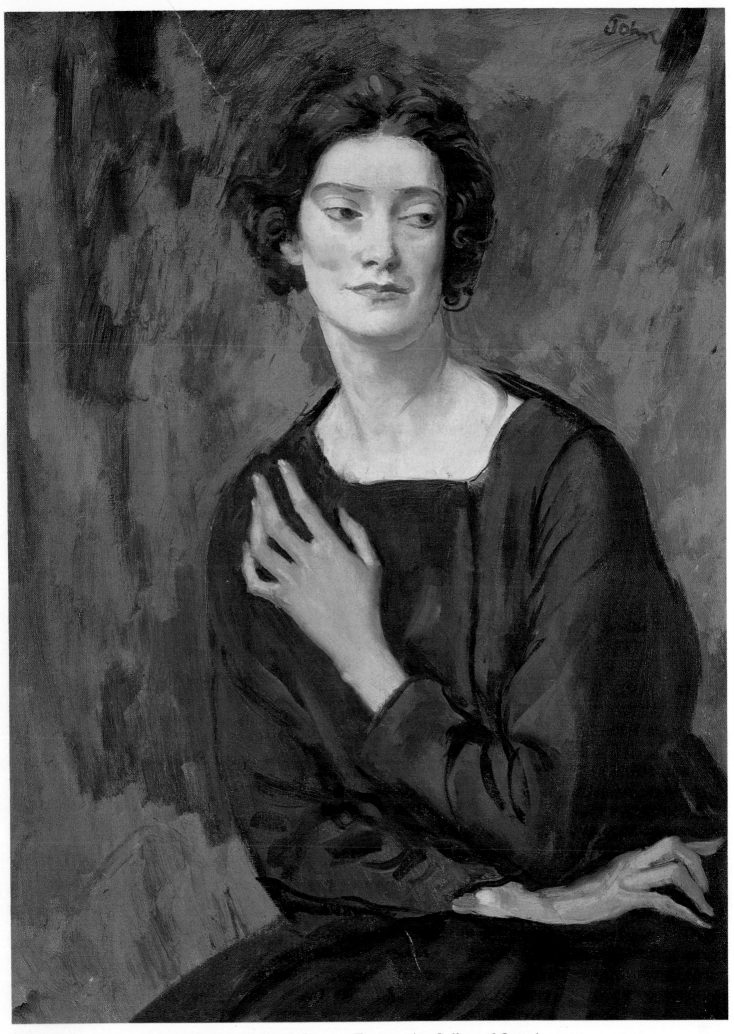

38. *Lady Cynthia Asquith: Portrait of a Lady in Black*. 1917. Toronto, Art Gallery of Ontario

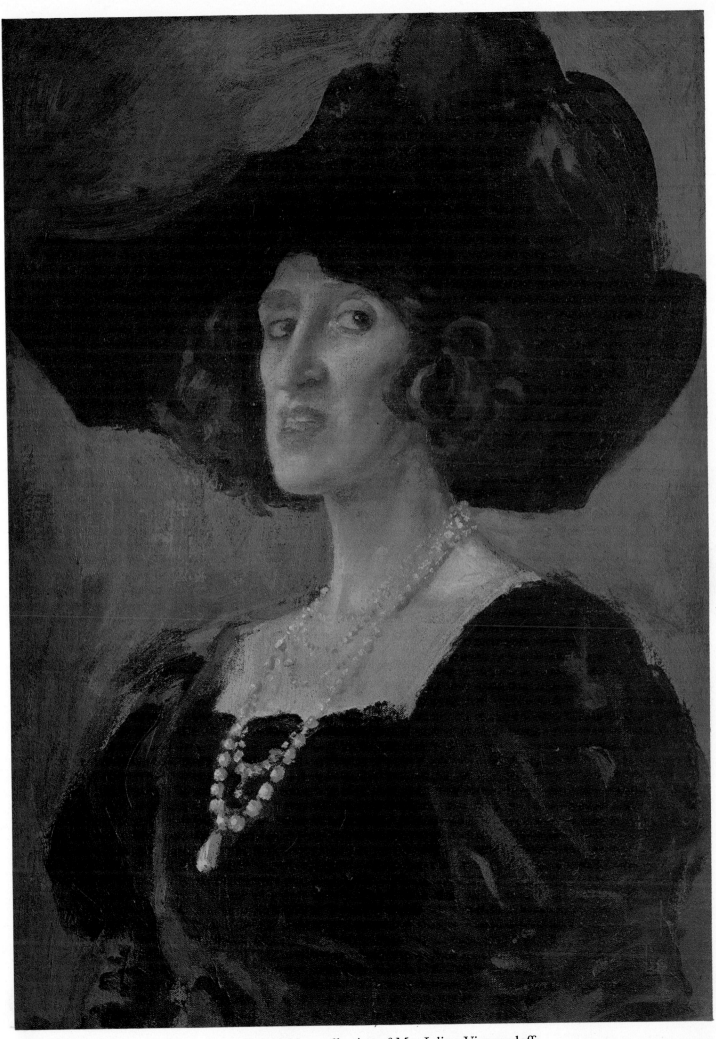

39. *Lady Ottoline Morrell*. About 1919. Oxfordshire, collection of Mrs Julian Vinogradoff

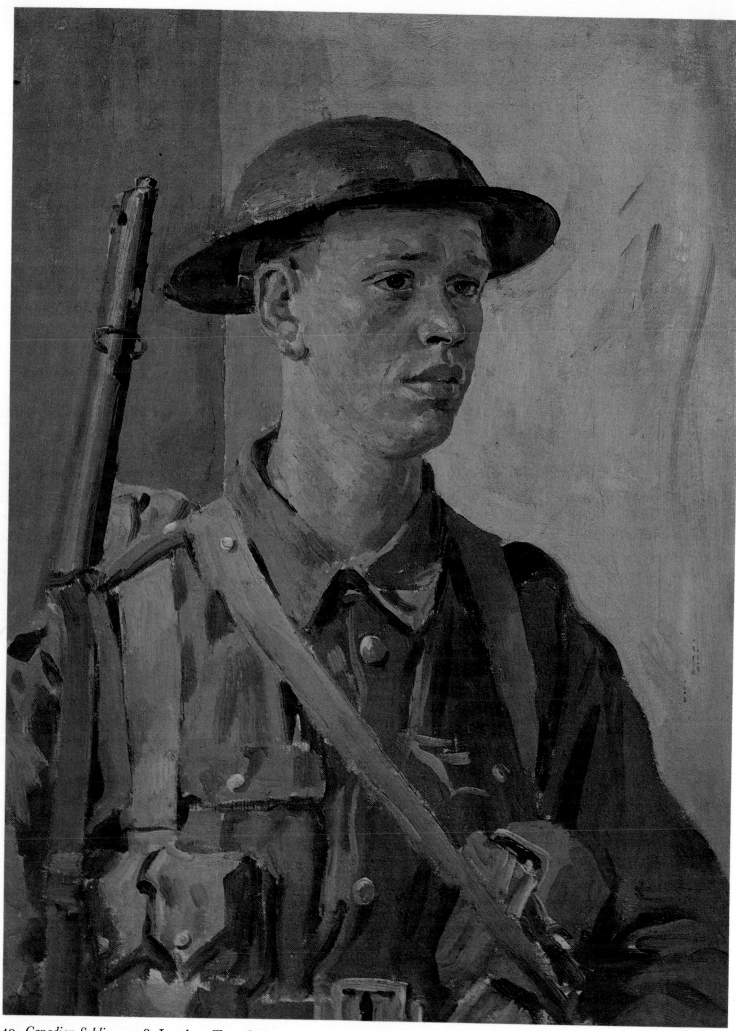

40. *Canadian Soldier*. 1918. London, Tate Gallery

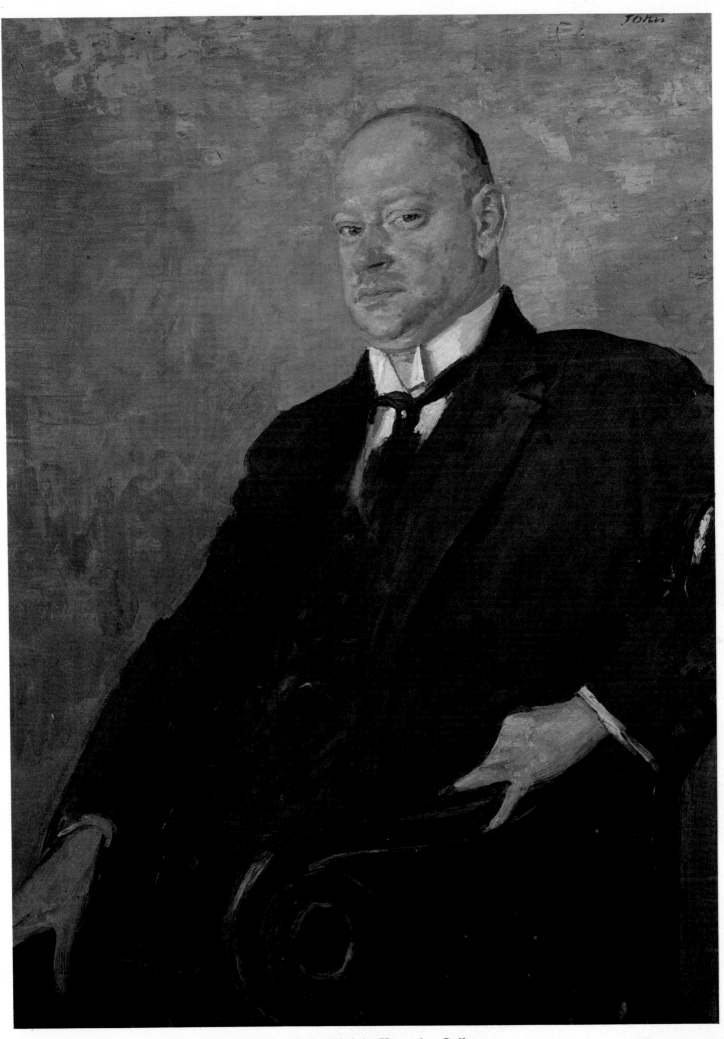

41. *Portrait of Gustav Stresemann.* 1925. Buffalo, N.Y., Albright-Knox Art Gallery

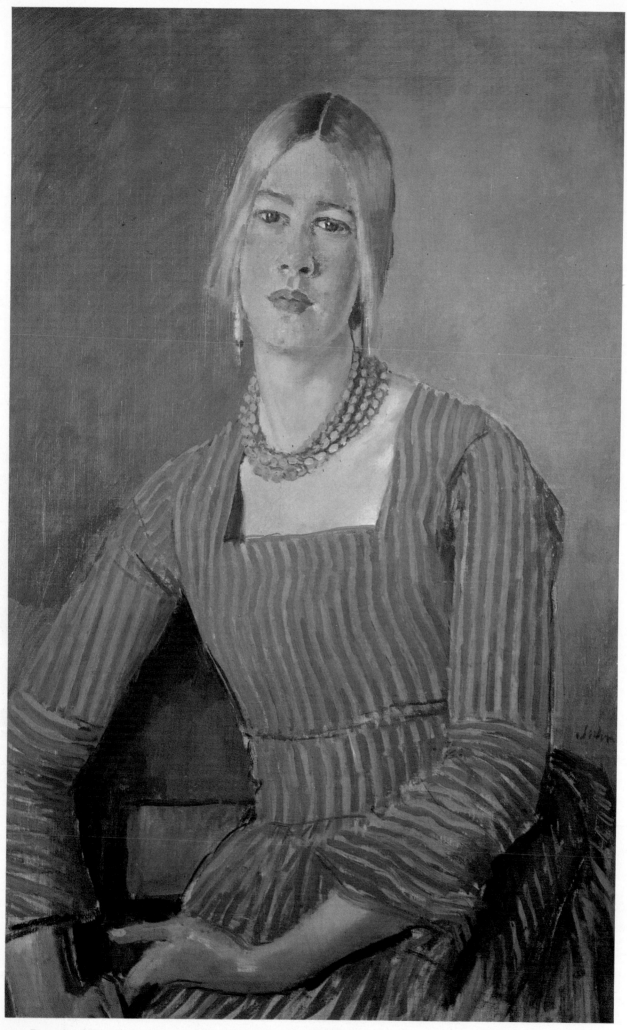

42. *Portrait of Eve Kirk*. About 1928. Rochdale Art Gallery

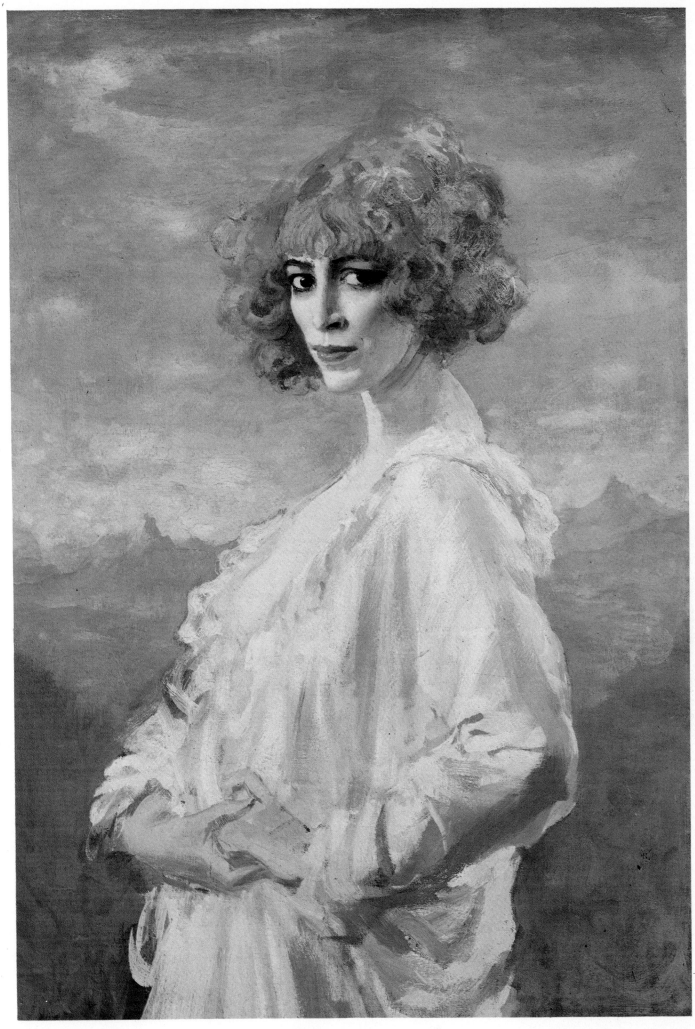

43. *The Marchesa Casati.* 1919. Toronto, Art Gallery of Ontario

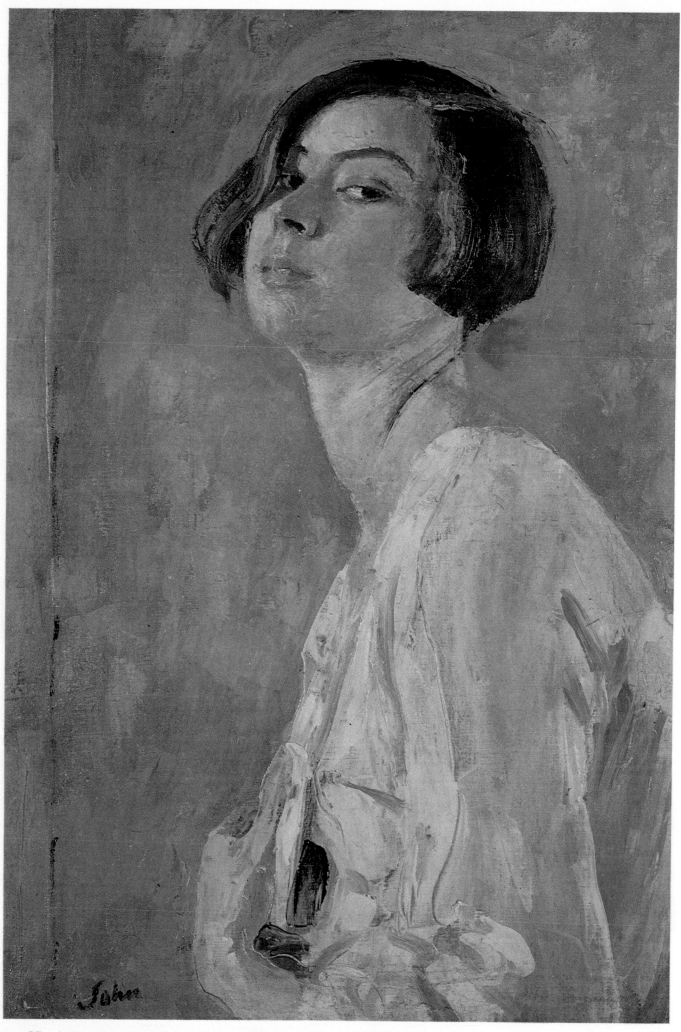

44. *The Artist's Daughter (Poppet)*. About 1927–8. Melbourne, National Gallery of Victoria

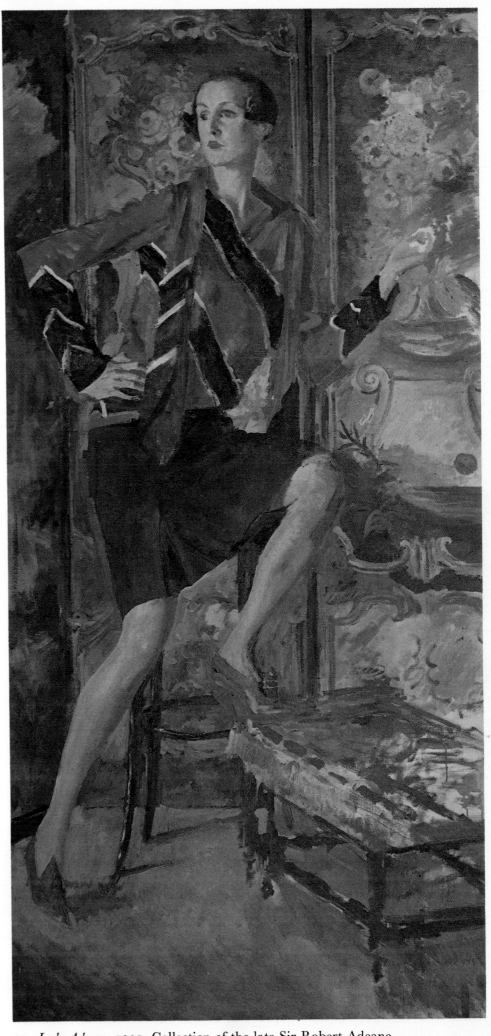

45. *Lady Adeane*. 1925. Collection of the late Sir Robert Adeane

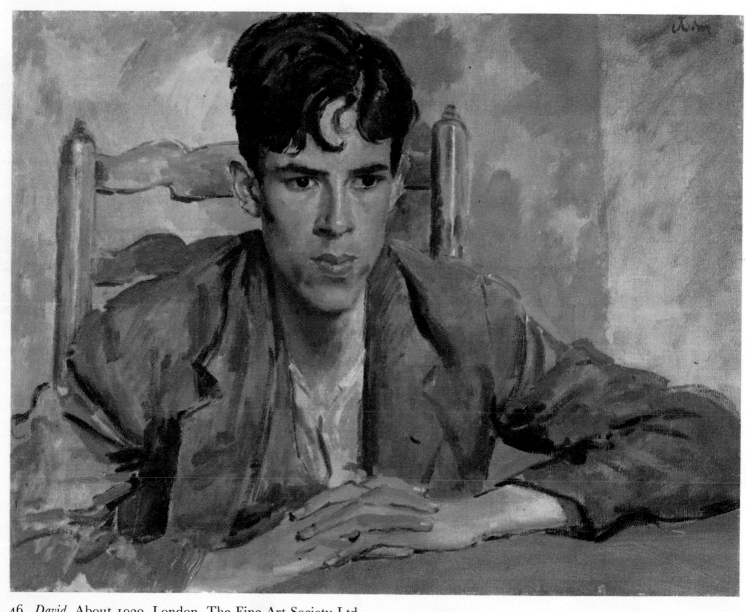

46. *David*. About 1920. London, The Fine Art Society Ltd.

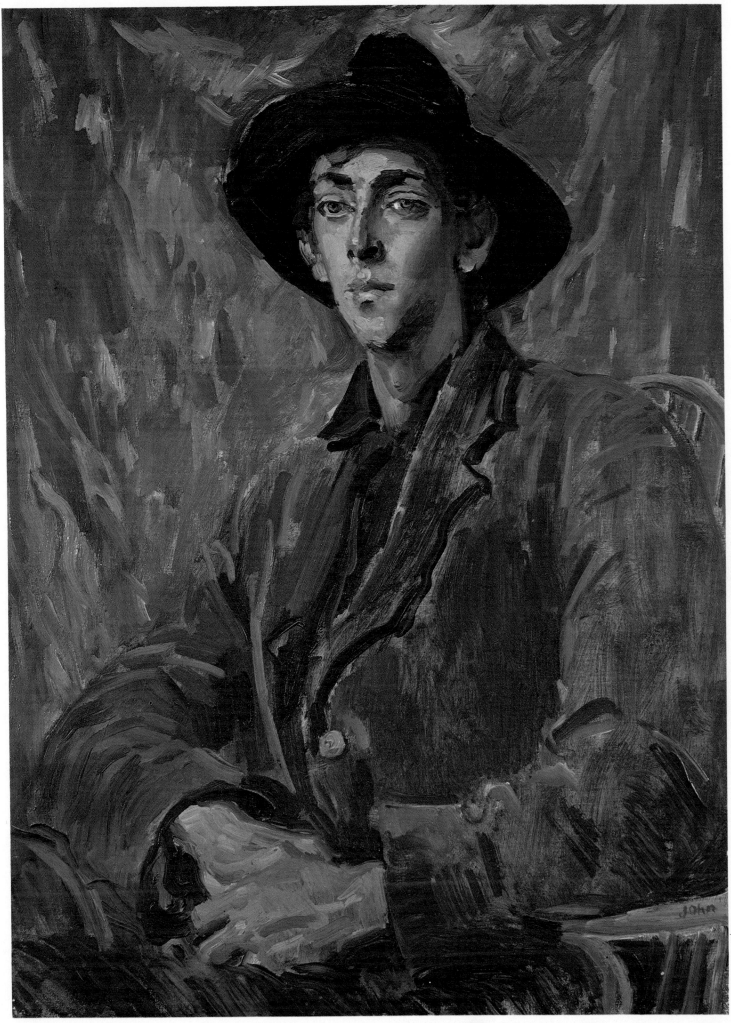

47. *The Poet Roy Campbell*. About 1930. Pittsburgh, Carnegie Institute, Museum of Art

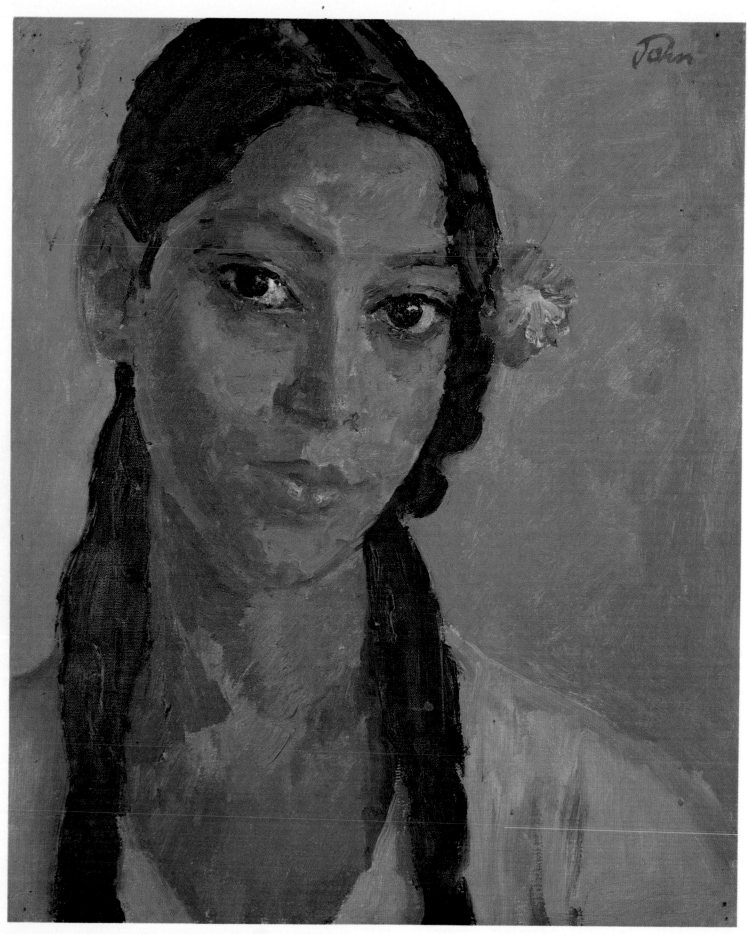

48. *Head of a Jamaican Girl.* 1937. Collection of Mr Richard Burrows

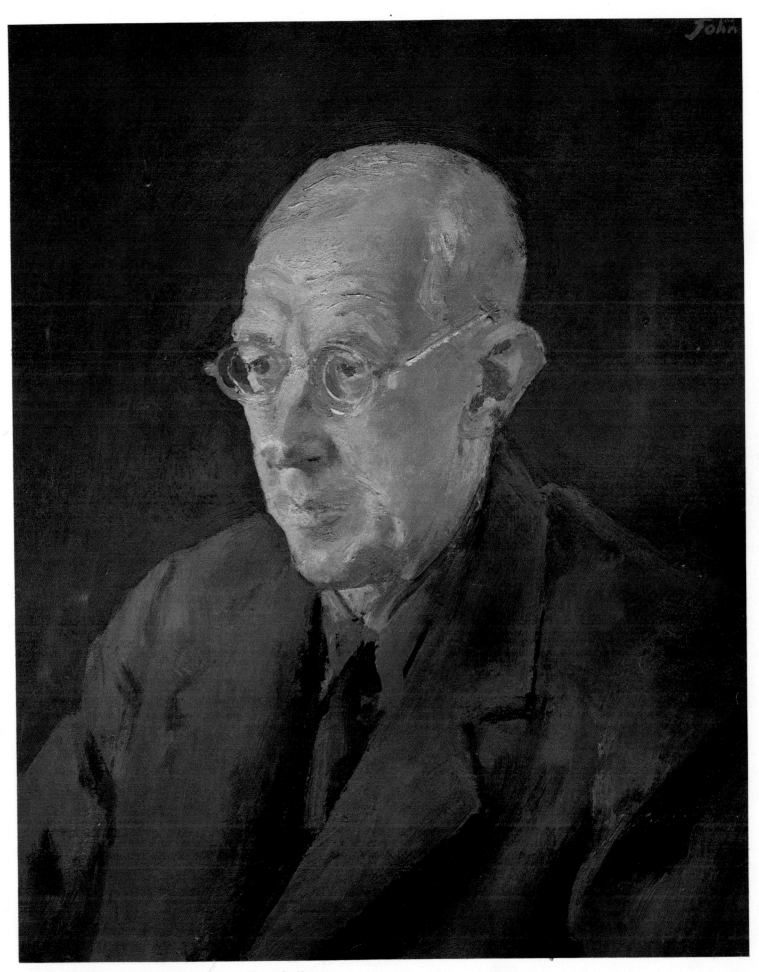

49. *Sir Matthew Smith.* 1944. London, Tate Gallery

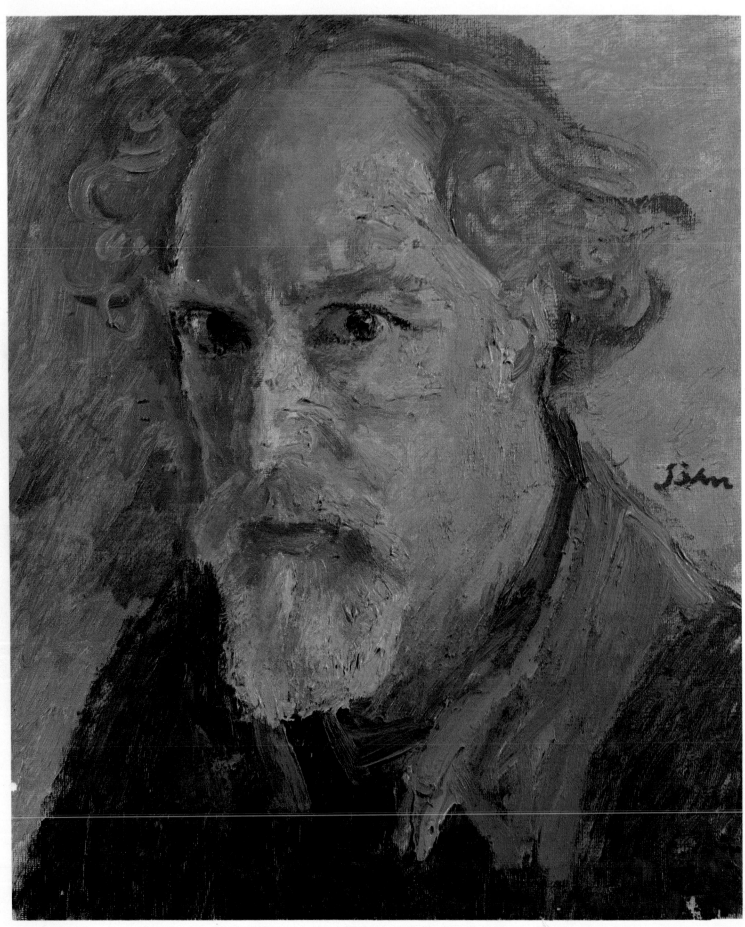

50. *Self-Portrait*. About 1938. London, collection of Mrs Thelma Cazalet-Keir